GLEN CANYON DAM
IMAGES of America

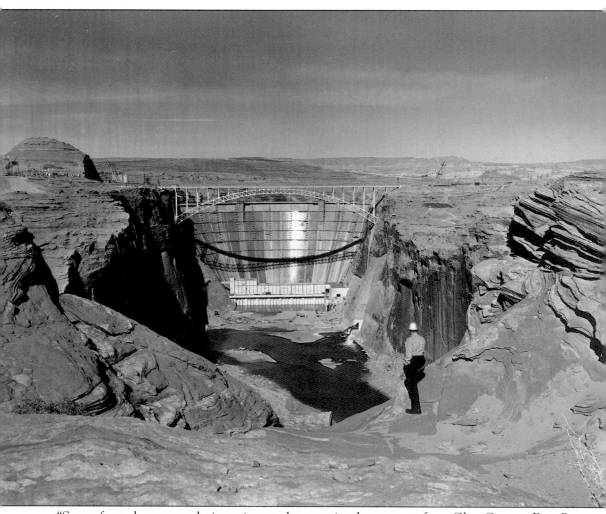

"Scene from the proposed viewpoint on the east rim downstream from Glen Canyon Dam." The last 12-yard bucket of concrete was placed on September 13, 1963, some two months prior to this photograph being taken. (Courtesy of Bureau of Reclamation, photo by A.E. Turner, P-557-420-9092, 11-22-63.)

IMAGES of America
GLEN CANYON DAM

Timothy L. Parks

ARCADIA
PUBLISHING

Copyright © 2004 by Timothy L. Parks
ISBN 978-0-7385-2875-5

Published by Arcadia Publishing
Charleston, South Carolina

Printed in the United States of America

Library of Congress Catalog Card Number: 2004100457

For all general information contact Arcadia Publishing at:
Telephone 843-853-2070
Fax 843-853-0044
E-Mail sales@arcadiapublishing.com
For customer service and orders:
Toll-Free 1-888-313-2665

Visit us on the Internet at www.arcadiapublishing.com

Contents

Acknowledgments 6

Introduction 7

1. The Idea and the Right Location in the Canyon 9

2. Before the Dam Could Be Built 13

3. Diverting the Waters of the Mighty Colorado River 25

4. Five Million Yards of Concrete 31

5. Backing Up the Waters of the Mighty Colorado 93

Acknowledgments

When I first came across the pictures used in this book I did not know right away what to do with them. At their very existence, at the extreme detail found in each 8-by-10 photograph—all them being 8-by-10 images—I gazed at and into them in awe. I knew that I surely must do something.

Some, not all of them, I found to be numbered; the last photograph used in this book is designated number 10290. Since I placed the photographs in the book chronologically, except where layout necessitated a slight reordering, and since the numbering followed the order of time, one could safely assume there are not too many more that follow that image number 10290.

Of that total number of Bureau of Reclamation photos, I had a cache of roughly three percent of the photographs that were taken during the construction of Glen Canyon Dam, a period of almost ten years. Not all of the images were Bureau of Reclamation photos. Some were photographs taken by general contractor Merritt-Chapman & Scott Corporation, and a few were taken by Interstate Photographers out of New York City. Still others were simply unidentified as to who had shot them.

Specific images depicted milestones in the life of the project, and certain images were familiar, for they are those used in advertisements, in magazines, and in newspapers that covered the project from its onset and as it progressed until it was finished. This lost treasure of images was special, of that I was certain. In my hands I held history.

The descriptive writing that accompanies some of the images is not noted as being written by any one person, in fact not one name is mentioned. I have, nevertheless, used that original text and retained each just as it was written, quoting the caption word for word, editorializing afterwards only to elaborate on the subject matter if necessary. To the nameless writer, or writers, of this quoted text a great measure of indebtedness is deserved. For who could better explain what each shot was than one who was there.

Whenever possible, when credit is given to the photographer, I have passed along that credit in using their photographs in this book. Those photographers who lugged around heavy and bulky large-format cameras on tripods and took these stunning photos were more than likely paid to do so, and perhaps to them it was just a job . . . but I doubt it! In each image there is an artistic expression of place and time, of composition, of light and contrast. There was deliberate thought given to that moment when the shutter was released. Behind the cameras were men who knew what they were doing and what the desired result should be. F.S. Finch, W.L. Rusho, Stan Rashussen, Omer Hill, Mel Davis, and especially A.E. Turner contributed what is the single most important aspect to a book such as this—rare images of a time now past and gone forever.

To that person who held tight to these photographs for so very long before they fell into my hands I am thankful, and the observers and readers of this book will most assuredly be so too.
I am grateful for Kathie, who like an angel from God above, is forever ahead of me pulling, behind me pushing, or right at my side helping in whatever it is I endeavor to do.

I dedicate this book to all those who worked on the Glen Canyon Dam Project—what a marvelous feat.

And for so many good reasons, it is also dedicated to my good friend Jack Edward Highers.

—Timothy L. Parks

Introduction

Behind it would sit Lake Powell, the second largest man-made body of water in the United States, though the length of the lake and its miles of shoreline far surpassed that of Lake Mead, which was greater by volume and just 300 miles away. Access, from one side of the deep Glen Canyon to the other, would be made possible by the design and erection of, at the time, the highest and longest steel arched bridge in the United States, Glen Canyon Bridge.

For the Bureau of Reclamation, it was the 149th dam to be built, and it would be second in height to only one other, Hoover Dam. But in terms of mass, Glen Canyon Dam would be the largest—it was a dam builder's dream—and in 1956, to remote northeastern Arizona, many of these dam builders arrived to take on the task.

Officially, work on the project began October 1, 1956. Ceremoniously, however, it began October 15, 1956 when the first detonation of charges to begin excavations was triggered by President Dwight D. Eisenhower as he pressed a key so many miles away in Washington, D.C. It was much more than a typical groundbreaking, one replete with gold-plated shovels, when those first huge slabs of Navajo sandstone came crashing down from the steep canyon wall of Glen Canyon into the river below. It was earth-shattering!

Glen Canyon Dam, the literal concrete structure, was erected over a period of time from 1960 through 1963, but prior to its actual construction—the non-stop pouring of 5 million yards of concrete—much work had to be done.

A bridge, the Glen Canyon Bridge, had to be built to span Glen Canyon so that men, materials, and equipment could move and be moved from one side of the canyon to the other without having to travel the roughly 200 round-trip miles it would take otherwise. The steel arch design, Glen Canyon Bridge was shipped in pieces to the site and was erected between 1957 and 1959.

To go with the bridge, a road was built. Existing U.S. Highway 89 was re-routed to connect with each side of the new Glen Canyon Bridge. From the north, Highway 89 at Kanab, Utah was brought east across southern Utah then dropped south into Arizona to connect with the west side of Glen Canyon Bridge. Then from the south, Highway 89 was extended north from Bitter Springs, Arizona to connect with the east side of the bridge. The new stretches of highway and Glen Canyon Bridge meant that it was only a quarter-mile trip to get from one side of the canyon to the other.

A town also had to be created since the workmen and their families would need someplace to live nearby. Page, Arizona, which began life as Page Government Camp, was founded on the high, windswept Manson Mesa just south and east of the dam site. On Thanksgiving Day, 1957, the first workers—a few with their families—moved into the newly built cinder block houses. It was not until 1975, 12 years after completion of the dam that Page was incorporated as a city in the state of Arizona.

Before the actual dam construction could begin, work on the two facing canyon walls had to be done. An access tunnel was blasted and carved out of the east face to allow trucks and equipment passage from the canyon rim to the river bottom. Diversion tunnels—two of them, one on each side—were bored and lined with concrete so the mighty Colorado River might be skewed off its course and the dam allowed to rise from a dry canyon floor. The Colorado River was diverted on February 11, 1959. Excavation for the dam foundation was completed at a depth of 127 feet below

the river bottom, and on June 17, 1960, the first concrete was placed. Pours continued non-stop until September 13, 1963, when the last concrete pour on the dam was made.

Some months prior to topping out the dam structure the first storage of water behind Glen Canyon Dam began, that occurred on March 13, 1963. After the dam was completed, work installing electric generating turbines was performed from 1963 until 1966, and the first electricity was generated on September 4, 1964.

Nearly ten years after work first began, Glen Canyon Dam was dedicated on September 22, 1966. Mrs. Lyndon Johnson performed the dedication before the thousands in attendance, and the following August, the Carl T. Hayden Visitor Center was opened to the public. Native Arizonan Carl T. Hayden had served the state of Arizona in the United Sates Congress for 57 years and was an influential supporter of water reclamation projects such as this one.

Finally, on June 22, 1980, a final milestone was achieved—Lake Powell was filled for the first time. Then, on July 14, 1983, it filled again. In fact, the runoff that year was so great that a temporary eight-foot concrete wall was built on top of the dam and water was released as much and as fast as could be so that it did not overtop the dam. The peak discharge that year was 100,000 cubic feet per second. Heavy spring runoffs continued in 1984, 1985, and 1986, and discharges of 40,000 to 50,000 cubic feet per second had to be maintained for a month or so each year during peak runoff from the Colorado River watershed above.

Despite the controversy that brewed over this project, even years before the site was actually chosen (a controversy that is stronger and more alive today than it was even then), it is undeniable that the construction of Glen Canyon Dam was spectacular. To quote Lem Wylie, the project construction engineer for the Bureau of Reclamation, "Never before has a large dam been built in such a colorful and magnificent desert scenery. There can be only one Glen Canyon Dam."

How the Colorado River ran through a deep and desolate Glen Canyon before the dam; how its waters backed up behind the newly constructed dam and glossed over Glen Canyon; how the past and present debate over the dam's very existence has raged—these matters are not the story told here. Rather, it is the faint and gray, sometimes forgotten period of time brought back to life in images, bound together with succinct words, that recall the great efforts of persevering men some 40 years ago. This story in pictures is the construction of Glen Canyon Dam.

One

THE IDEA AND THE RIGHT LOCATION IN THE CANYON

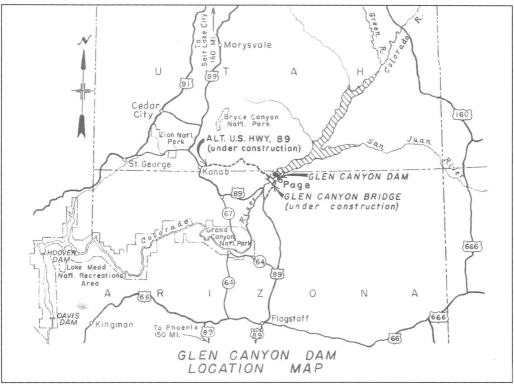

This original location map for the yet-to-be-built Glen Canyon Dam focused on the immediate area affected by the overall project. Although the dam itself and the new Glen Canyon Bridge were built in northern Arizona, southern Utah is where most of Alternate U.S. Highway 89 was built and also where most of the backed-up waters of Lake Powell would lie. Judging from the notation that both Alternate Highway 89 and Glen Canyon bridge were "under construction," this map was likely printed and distributed sometime in late 1957. Of particular interest is the so very well-known U.S. Highway 66. It had not yet been widened, divided, re-routed, and re-named Interstate 40. In fact, all the highways on this map are designated as a U.S. Highway as there was no Interstate Highway System.

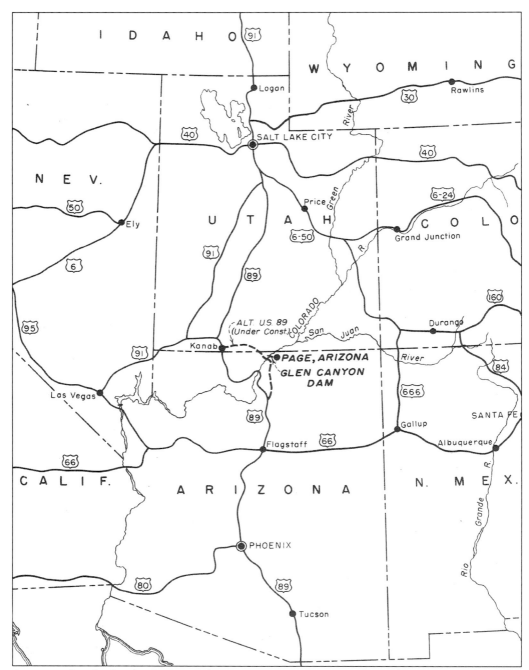

As opposed to the localized map on the previous page, this original issue location map shows the region and the states surrounding the affected area. The headwaters of the Colorado River can be seen where they originate in north central Colorado. The main tributaries of the Colorado River—the Green River, with its origins in far northwestern Wyoming, and the San Juan River, originating in southern Colorado—both flow into the Colorado River in southeastern Utah.

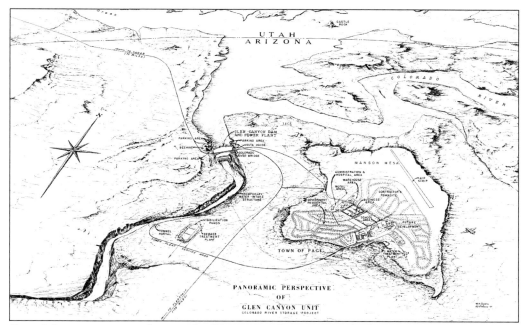

Out of the imagination of many, the "Panoramic Perspective of Glen Canyon Unit, Colorado River Storage Project" was a vision of the future in a place where there was nothing save only the rocks, Glen Canyon, and the Colorado River. It all had to be built—a town, new highways, a bridge, all of which preceded construction of the dam. (Courtesy of Bureau of Reclamation, prepared by W.M. Shideler and J.T. Vitaliano, P-557-D-A-4, 1959.)

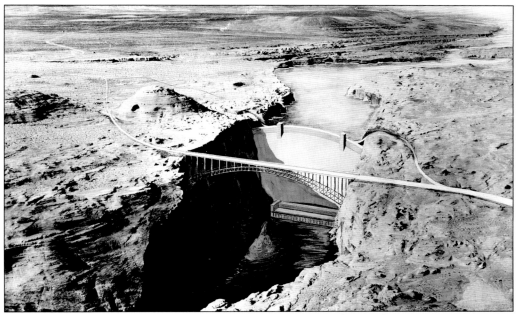

Prepared, of course, prior to commencement of the project, this rendering is amazing in just how closely it matches the dam and bridge after both were built and the waters backed up behind Glen Canyon Dam. (Courtesy of Bureau of Reclamation.)

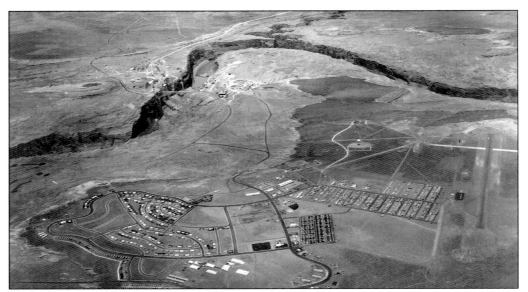

"In foreground is Page, Arizona, a modern city with facilities to serve a population of 8,000 that has been built in the desert two miles southeast of the site of Glen Canyon Dam. Facilities include homes, stores, churches, a hospital, schools and recreational facilities. In background is Glen Canyon, with contractor's construction base on both sides of the gorge." After the Glen Canyon Project, the population of Page dropped off to 1,500 diehards but has increased since that time. (Courtesy of Bureau of Reclamation.)

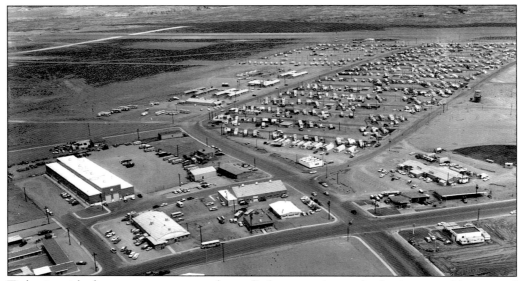

To begin with there were no trees and very little vegetation, only the incessant blowing red sands of Manson Mesa. Then Page was invented. Life was rough at first, and the workers, along with those who came to serve their needs, were like pioneers. The dam workers lived in what was then thought to be the largest trailer park in the world—the dwellings, however, at that time were called transa-houses. All of the varied residents of Page co-existed well together, and just as in the towns of the Old West, they were actually very dependent upon one another for many things. (Courtesy of Bureau of Reclamation.)

Two

BEFORE THE DAM COULD BE BUILT

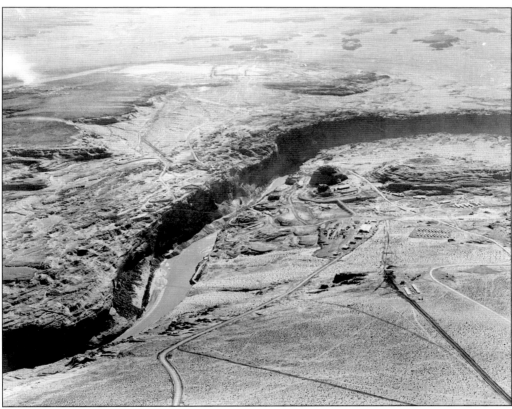

An early aerial photograph of Glen Canyon, looking south before Glen Canyon Bridge had been built and construction of the dam had begun, provides an idea of what the area once looked like. The dam location, in about the center of the photograph, was the final site of several chosen for Glen Canyon Dam, about 15 miles upriver from Lee's Ferry. Construction was underway on the two pieces of roadway to link Highway 89 at Glen Canyon once the bridge was in place. The faint line of the "chickenwire" footbridge can be seen just left of center. There is evidence of much pre-construction activity on both the west and east sides of the canyon. (Courtesy of Bureau of Reclamation, photo by F.S. Finch, 11-26-57.)

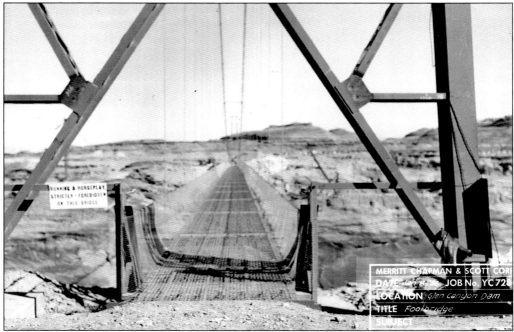

A "chickenwire" footbridge was strung across Glen Canyon in January of 1958, allowing workmen a shaky passage from one side of the canyon rim to the other. (Courtesy of Merritt-Chapman & Scott, 1-13-58.)

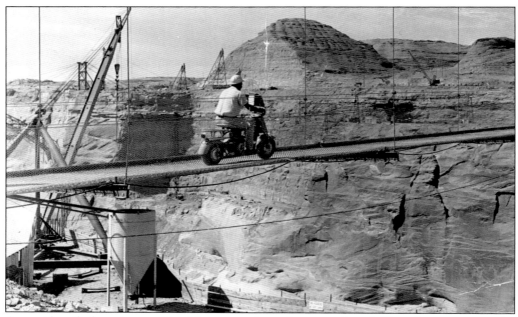

An unidentified workman rides his scooter from the east side of Glen Canyon across the footbridge. He appears undaunted both by the seemingly frail structure and by the fact that it was built as a footbridge. (Courtesy of Waynette Willis, provided in remembrance of her father who worked on the dam.)

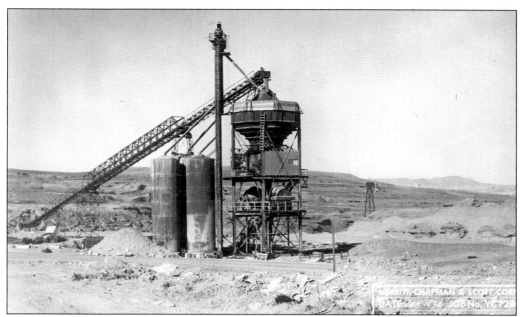

It is uncertain what exact needs were filled by this small, preliminary batch plant, located on the west side of the canyon not too far from the right (west) spillway. (Courtesy of Merritt-Chapman & Scott, 1-13-58.)

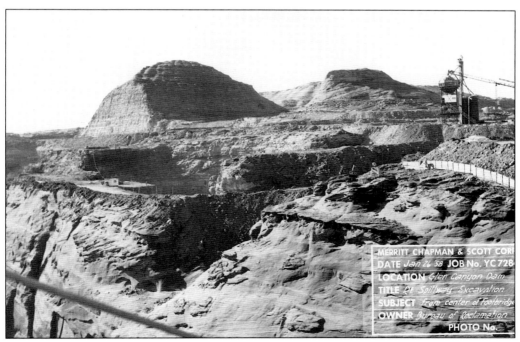

The right (west) spillway excavation is pictured from a vantage point at the center of the "chickenwire" footbridge, looking southwest. The purpose of the spillway was to release large amounts of water when the lake level behind the dam became high with heavy runoff from the watershed above. (Courtesy of Merritt-Chapman & Scott, photo #12 in a series, 1-26-58.)

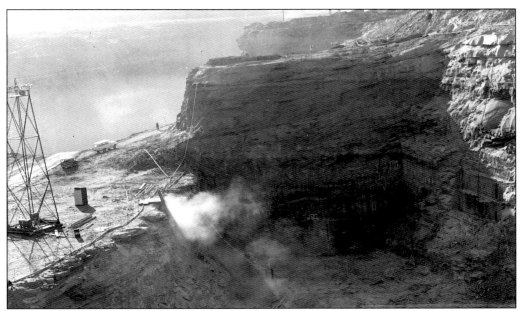

After drilling and setting charges, a blast is detonated, freeing up more Navajo sandstone while work continues on the right (west) spillway. (Courtesy of Merritt-Chapman & Scott, 1-16-58.)

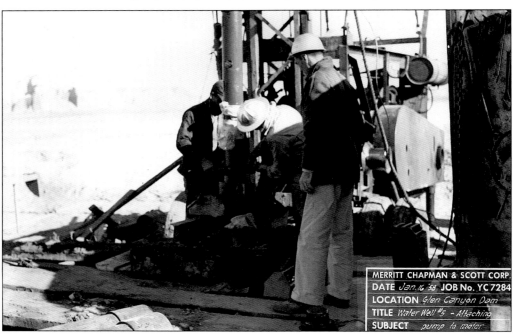

At Wahweap Creek, workmen attach a pump to the motor at water well #5. "Mile 15" dam site was chosen in part due to its close proximity to Wahweap Creek and its ample supply of aggregate (rock and gravel) to be used in batching the five million yards of concrete it would take to build Glen Canyon Dam. The concrete batching plant three short miles from the dam site was very important in maintaining the budget, schedule, and quality of the concrete. (Courtesy of Merritt-Chapman & Scott, 1-16-58.)

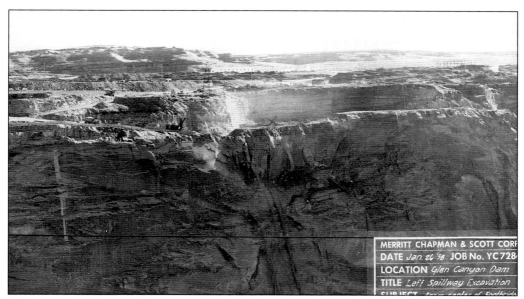

The excavation of the Glen Canyon Dam left (east) spillway is seen here in a view taken from the center of the "chickenwire" footbridge looking southeast. (Courtesy of Merritt-Chapman & Scott, 1-26-58.)

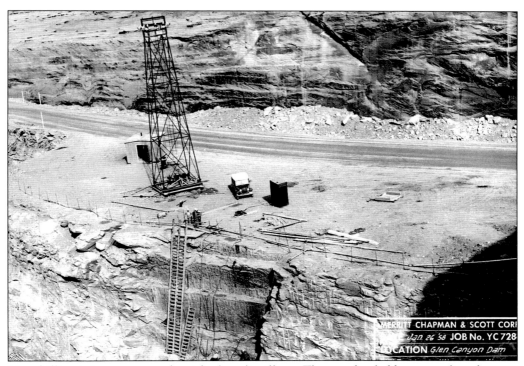

Line drilling is in progress at the right (west) spillway. The wooden ladders extending down to the work area differ little, if any, from those constructed and used on construction sites today. Above the work is a lighting tower, what appears to be a job shack of some sort, and a portable toilet. (Courtesy of Merritt-Chapman & Scott, 1-26-58.)

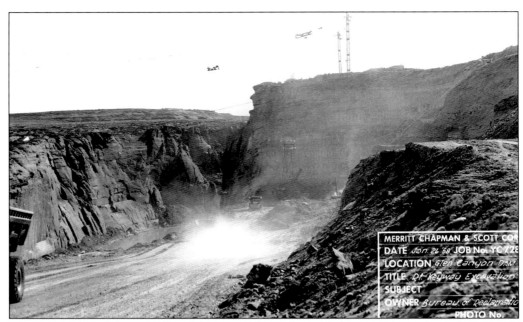

The excavation of the right (west) keyway—the wide vertical cuts made in the rock that each side of the dam is built into—can be seen through the dust on the haul road. The dust was created by a monstrous Euclid end dump truck just loaded and on its way back up. Another Euclid is being loaded at the cut. The work went on day and night as evidenced by the lighting tower. (Courtesy of Merritt-Chapman & Scott, 1-26-58.)

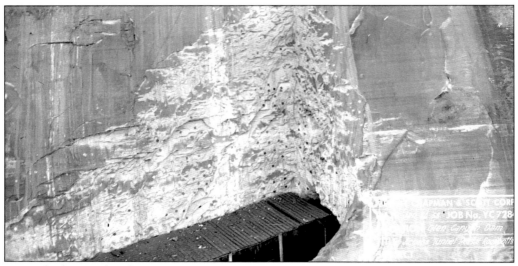

Two miles long and with an average grade of eight percent, an access tunnel with a service road inside it was bored out of the east face of the canyon. It ran inside and parallel to the canyon's rock face, allowing men and equipment to traverse the canyon rim to the river canyon bottom floor. It was built 20 feet in diameter, and windows called adits were blasted out from the tunnel into the canyon about every 500 feet. Initially, rock excavated from the tunnel was simply pushed out and down into the canyon as opposed to spending the time, trouble, and expense of hauling it out. (Courtesy of Merritt-Chapman & Scott, 1-26-58.)

This aerial view, taken about May 1958, looks south along the straight stretch of Glen Canyon and the "Mile 15" site chosen for the dam. Cables stretching from steel towers on one canyon rim to steel towers on the other can be seen, and they comprise two cable systems. One is the cableway used in the actual construction and erection of Glen Canyon Bridge. The other is used to guy back and support each side of the steel arch bridge as each reached out over the canyon towards the other. When the center keystone of the bridge was set and bolted in place, the cableway system supporting the structure from each side was then relaxed, allowing the arched bridge to support itself as it was designed to do.

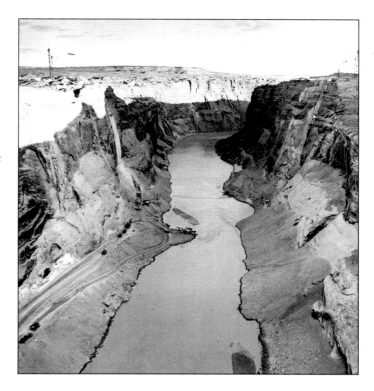

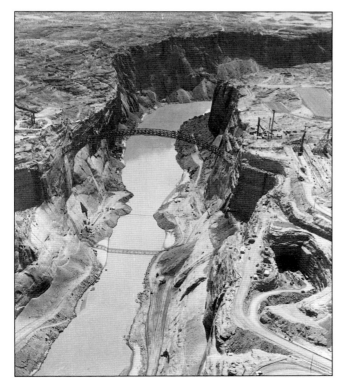

Looking south down Glen Canyon just four months later, about September of 1958, reveals a very different view. Glen Canyon Bridge, though not complete, spans the entire breadth of the canyon. The final truss—the center piece, the keystone—was slipped into place on August 6, 1958. It is said to have been off its mark by only one-quarter inch! But the cables were slightly adjusted and into place it went.

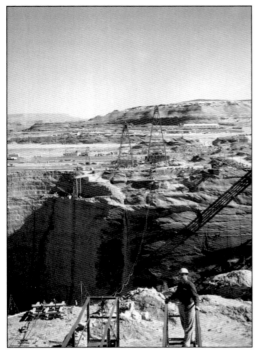 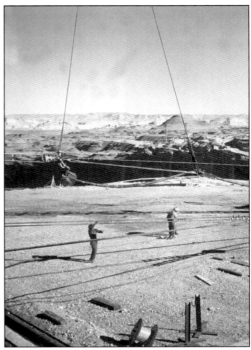

As in the construction of Glen Canyon Bridge, cableways were built to facilitate the construction of Glen Canyon Dam. Cable had to be taken across the canyon from the two steel head frames on the east rim to the two on the west so that each of the two 50-ton cableways could be put into use The four-inch-diameter cable weighed in at 38 pounds per lineal foot. The head frames, like a train, were on tracks so they could be moved north or south, positioned and repositioned for a particular lift or concrete pour. Two of the towers were shorter and located in front of their taller brothers, built this way to allow for both to be moved north to south along their respective tracks and operate at the same time. (Courtesy of Merritt-Chapman & Scott, 1958.)

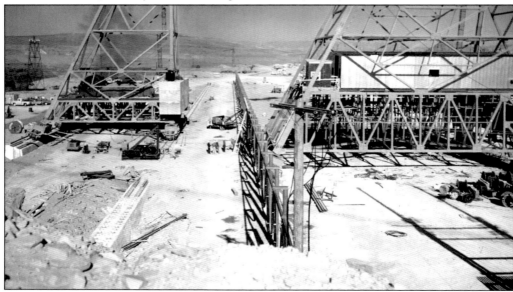

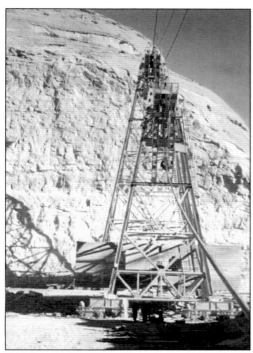 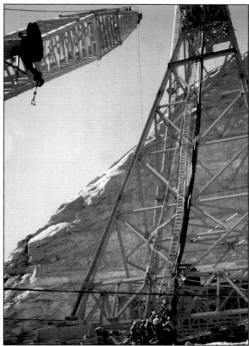

Prior to the pouring of concrete, the cableways were used to move everything across, into, and out of the canyon. After concrete pours began the primary purpose of these two cableways was to move the 12-yard buckets full of concrete from the batch plant and transfer trestle, into the canyon, and once discharged, back up again for another load. A smaller 25-ton cableway was erected shortly after the pours began to satisfy other needs; however, the 50-ton units were still called into service to move heavier items like a section of the powerplant (see pages 49, 63, 64). Both units had to be used together and in unison to perform this and other jobs like it. (Courtesy of Merritt-Chapman & Scott, May 1958.)

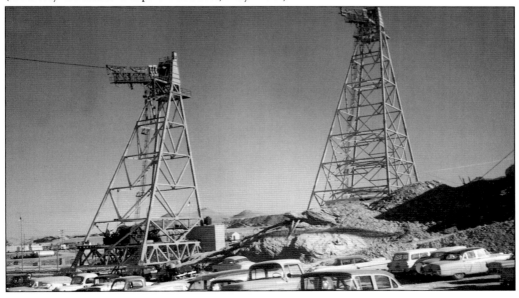

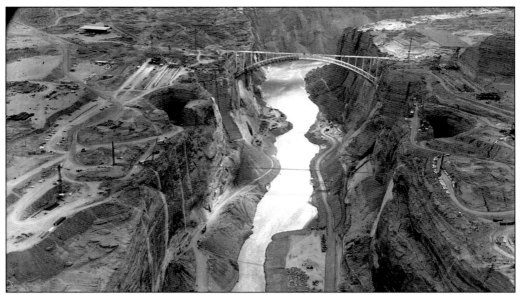

An almost completed Glen Canyon Bridge is in the background of this November 1958 southerly view of the canyon. Keyways continue to be cut, and the construction of the left (east) and right (west) spillways is visible. The "chickenwire" footbridge spans the canyon at just about the center of the photograph. Looking carefully near the bottom of the photograph, the upstream portal of each diversion tunnel can be seen on either side of the canyon.

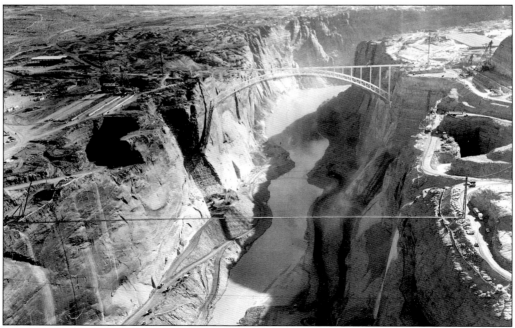

One month later, sometime in December of 1958, completion of Glen Canyon Bridge was near—it was dedicated February 20, 1959. Hundreds attended the ceremony held center span of the bridge. Bureau of Reclamation commissioner Wilbur A. Dexheimer, Utah governor George Clyde, and Arizona governor Paul Fannin officiated the chain cutting ceremony.

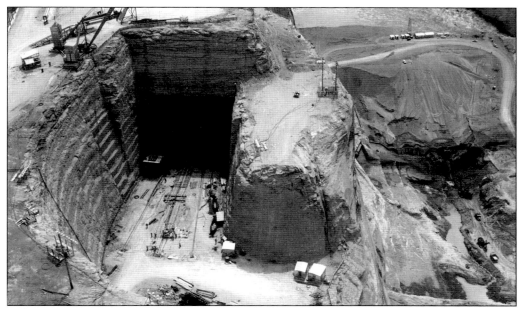

Left (east) spillway construction is on going while excavation for the dam foundation continues below. Required bedrock was found 127 feet below the original river channel. To the far right the diverted waters of the Colorado River can be seen rushing out of and along the west bank and canyon wall. (Courtesy of Bureau of Reclamation, 1959.)

Piping inside of the two-mile-long access tunnel is checked by a lone workman. From October 1957 until June 1958 the tunnel was bored simultaneously from each end, canyon rim to river bottom. The final charge, detonated on June 24, 1958, linked the two together. After use during the construction phase to transport materials, the tunnel later served as a direct service road from the canyon rim down to the power plant. (Courtesy of Bureau of Reclamation, 1959.)

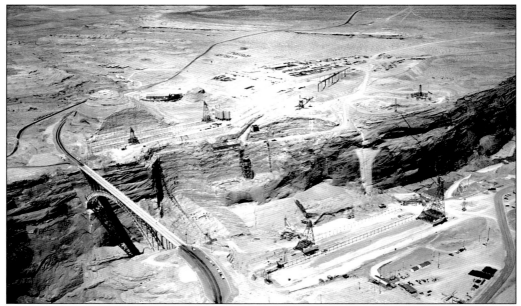

Looking west by northwest, Glen Canyon Bridge is complete and the new, rerouted Highway 89 rolls off to north and west, 76 miles to Kanab, Utah. The two cableways are poised just to the north of the bridge and the faint line of "chickenwire" foot bridge and its shadow can be seen on the far right.

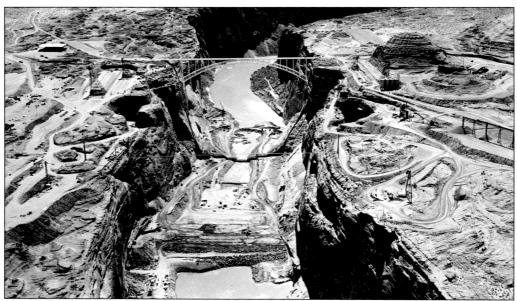

"At $108,000,000, giant Glen Canyon Dam on Arizona's Colorado River is the largest competitively-bid contract ever awarded to a single contractor. Being built by Merritt-Chapman & Scott for the United States Bureau of Reclamation, the dam will rise 700 feet across the 1200-foot-wide canyon. Its hydroelectric plant will have an output of some 900,000 kilowatts and the reservoir will supply irrigation to arid land in Arizona, Utah, New Mexico, Colorado and Wyoming." This view was taken looking south. (Courtesy of Bureau of Reclamation, May 1959.)

Three
DIVERTING THE WATERS OF THE MIGHTY COLORADO RIVER

In this photograph it appears that one is looking to the north—up river—through one of the giant tunnels used to divert the river while the dam was being built. Two diversion tunnels, 41 feet in diameter, were drilled and blasted through the canyon walls, and the 2,700-foot-long tunnels were then lined with concrete. Each tunnel was capable of carrying 100,000 cubic feet of water. Materials taken out as the tunnel was slowly lengthened were used to form the coffer dams that would block and drive the water of the Colorado into the tunnels. The right (west) tunnel was used primarily to carry the diverted waters around the dam site. The left (east) tunnel was built 33 feet higher than the west and was used as a back-up in case of heavy spring runoff from the Colorado River watershed. (Courtesy of Bureau of Reclamation, 1959.)

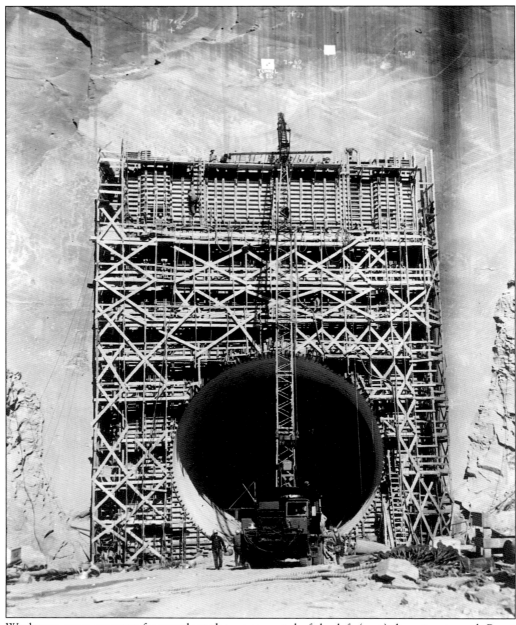

Workmen erect concrete formwork at the upper portal of the left (east) diversion tunnel. Pours were being made in conjunction with the installation of trash racks over the entry to prevent debris from entering the diversion tunnel. (Courtesy of Bureau of Reclamation, April 1959.)

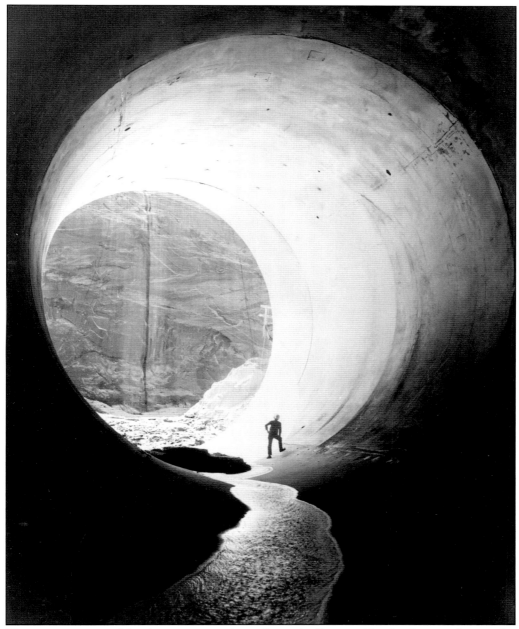
The enormous size of the diversion tunnels is effectively illustrated by this lone workman who is looking out of the discharge end of one of the tunnels. (Courtesy of Bureau of Reclamation, May 1959.)

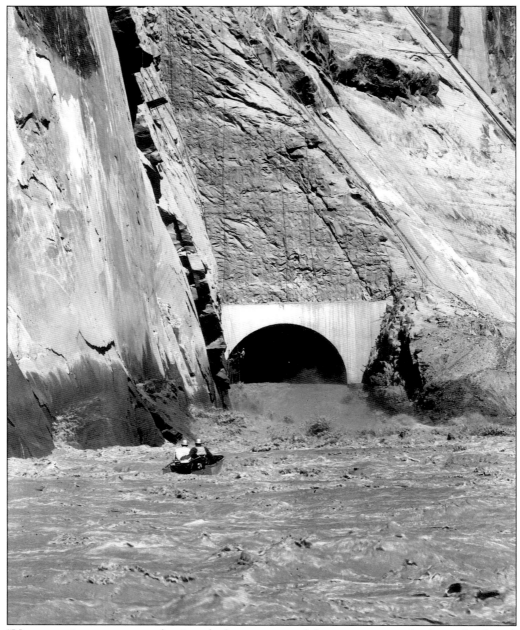

"Upstream into a man-made river bed, two intrepid boatmen approach the right (west) diversion tunnel carved through the rock on the west side of Glen Canyon that carries water of the Colorado River around the construction site of Glen Canyon Dam in Northern Arizona. Two such tunnels are being used to divert the river while the 707-foot-high concrete dam is being built." Look closely, the left side of the tunnel outlet is a high-scaler! Highscalers, men in harnesses suspended and dangling from ropes, performed a variety of tasks on the almost vertical walls of Glen Canyon that could not be done in any other manner. (Courtesy of Bureau of Reclamation, May 1959.)

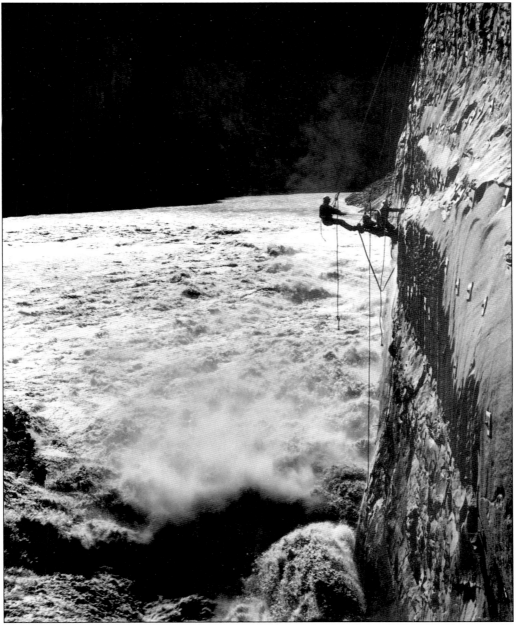

"Just over the roaring waters of the Colorado River, highscalers of Merritt-Chapman & Scott Corporation are suspended on the sheer (west) cliff which will form one side of the 707-foot-high Glen Canyon Dam in Northern Arizona. Highscalers prepare the canyon walls to serve as anchors for the 5,000,000 cubic yards of concrete that will form the nation's second highest dam." This photograph was entitled "Spacemen at Glen Canyon Damsite." (Courtesy of Bureau of Reclamation, May 1959.)

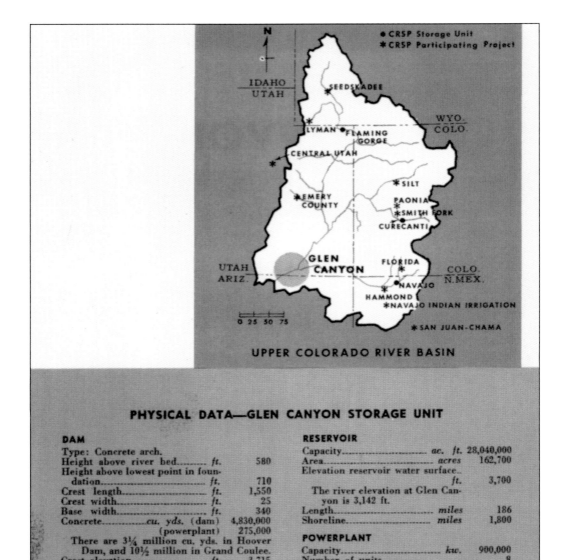

PHYSICAL DATA—GLEN CANYON STORAGE UNIT

DAM
Type: Concrete arch.	
Height above river bed............ ft.	580
Height above lowest point in foundation............ ft.	710
Crest length............ ft.	1,550
Crest width............ ft.	25
Base width............ ft.	340
Concrete............cu. yds. (dam)	4,830,000
(powerplant)	275,000
There are 3¼ million cu. yds. in Hoover Dam, and 10½ million in Grand Coulee.	
Crest elevation............ ft.	3,715
Maximum discharge through spillways............ sec. ft.	276,000

RESERVOIR
Capacity............ ac. ft.	28,040,000
Area............ acres	162,700
Elevation reservoir water surface............ ft.	3,700
The river elevation at Glen Canyon is 3,142 ft.	
Length............ miles	186
Shoreline............ miles	1,800

POWERPLANT
Capacity............ kw.	900,000
Number of units............	8
Capacity of each generator............kw.	112,500
Capacity of each turbine............ hp.	155,500

This is a page from a brochure, entitled "Glen Canyon Dam," that was printed and issued in 1963. The brochure provided an overview of the Upper Colorado River Basin, the area taken in and known as the Colorado River Storage Project. Staggering statistics and particulars of the Glen Canyon Dam were also provided. These are the facts given after the dam was completed; however, the conceptual and preliminary figures were either the same by design or were estimates very close to these actual facts. They are amazing to consider as the dam, seen in the pictures hereafter, begins to rise out of the bedrock, 127 feet below the river bed. (Courtesy of Bureau of Reclamation, December 1963.)

Four
FIVE MILLION YARDS OF CONCRETE

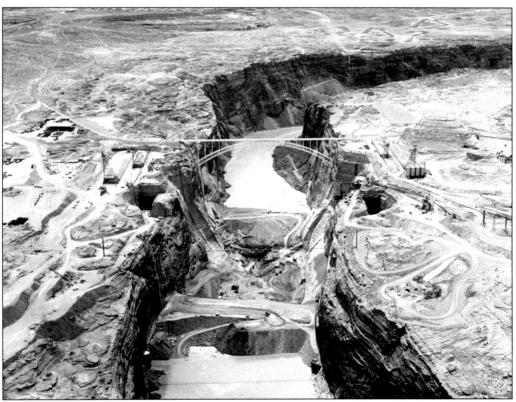

Compared to the image on the bottom of page 24, this photograph shows marked progress. The coffer dam, just north (at the bottom of photograph) of where the dam is to be built, appears to be complete, and on each side of the coffer dam the inlet for each of the two diversion tunnels is visible. Bedrock has not been hit, but must be close because the dam's foundation is nearing a point of readiness for formwork and the placement of concrete to begin. On Friday, June 17, 1960, the pouring of concrete began and it did not end until September 13, 1963, when the last 12-yard bucket was brought over by cableway and the last pour made. (Courtesy of Bureau of Reclamation, December 1959.)

Still under construction here, the batch plant was located on a shelf cut some 400 feet above the river bottom. At 217 feet tall, it was the world's largest concrete batch plant, capable of producing more than 400 cubic yards of concrete every hour. Above, and supporting the actual batching of as many as 12 different mix designs (only one was produced at a time), was a myriad of silos and bins, stockpiles of aggregate, and conveyors, along with a series of mechanical methods to cool both the materials as they went into the mix and the concrete itself. The concrete was placed at a specified temperature of 40 to 50 degrees, maintained at 50 degrees while curing, and when joints were grouted, the temperature lowered to 40 degrees. All of this was to achieve a very high strength concrete that would have minimal cracking. (Both courtesy of Merritt-Chapman & Scott, December 1959.)

The design and fabrication of the batch plant was given by Merritt-Chapman & Scott to a firm out of California, The Nobel Company. To ensure it could run at specified capacity, and do so non-stop for four years, a working model, one-eighth the size of the actual plant, was constructed and rigorous testing performed on it prior to fabricating, shipping, and erecting the real thing on site early in 1959. (Courtesy of Merritt-Chapman & Scott, December 1959.)

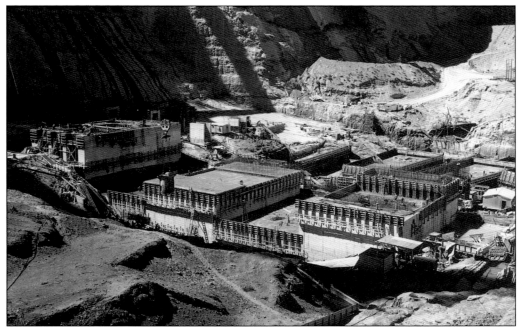

"Looking upstream at the concrete placement on the Glen Canyon Dam and powerplant. Powerplant in foreground." At left and center is one of the 12-yard concrete buckets suspended from vertical cables extending from the horizontal canyon rim to the canyon rim cableway. (Courtesy of Bureau of Reclamation, photo by A.E. Turner, P-557-420-5242, 9-8-60.)

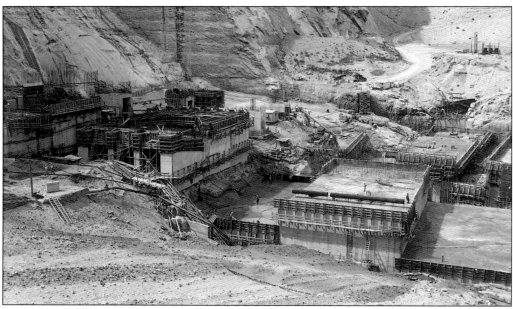

Mass concrete placement is well underway in this view of the west side of the powerplant. Each concrete block is at a different elevation as the structure is built up from the bedrock foundation upon which the powerplant and dam were built. (Courtesy of Bureau of Reclamation, photo by A.E. Turner, P-557-420-5230, 9-1-60.)

"Wedge shaped, concrete blocks rise slowly and massively from the rock floor of Glen Canyon. Blocks of the dam appear in the foreground and those of the powerplant are just downstream." (Courtesy of Bureau of Reclamation, photo by A.E. Turner, P-557-420-5247, 9-15-60.)

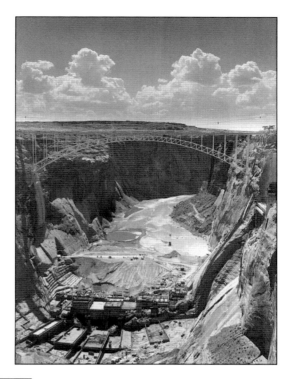

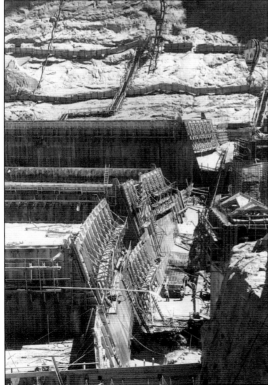

"The radius of the dam assumes shape as concrete placement progresses." Two rows of 24 wedge-shaped concrete blocks abutting each other, plus wedge blocks at each keyway, comprised the dam structure. (Courtesy of Bureau of Reclamation, photo by A.E. Turner, P-557-420-5281, 9-16-60.)

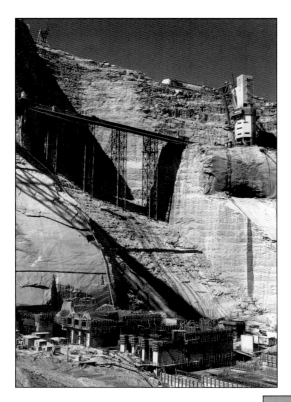

"Looking upstream over the west end of the powerplant. Concrete batch plant and transfer trestle on cliff wall." (Courtesy of Bureau of Reclamation, photo by A.E. Turner, P557-420-5303, 9-26-60.)

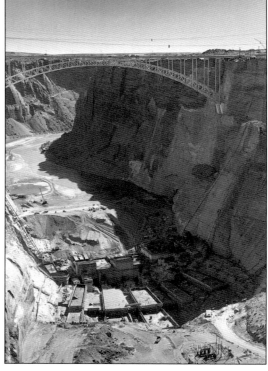

"General view of the Glen Canyon Damsite looking [south] downstream." The largest dam blocks were 60 by 210 feet. Each block was brought up in lifts, and each lift was $7^{1}/_{2}$ feet. Bedrock, where the foundation of the dam began at 127 feet below the river bottom, is very evident in this photograph. (Courtesy of Bureau of Reclamation, photo by A.E. Turner, 557-420-5340, 10-5-60.)

More than one advertisement was made on the site to promote the equipment being used to build Glen Canyon Dam. (Courtesy of Waynette Willis, provided in remembrance of her father who worked on the dam; courtesy of Bureau of Reclamation, photo by A.E. Turner, P-557-420-05382, 10-23-60.)

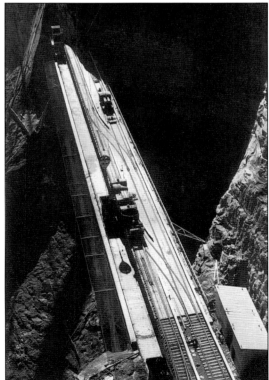

"Concrete ladle car empties its load into the concrete bucket on the trestle high on the right keyway. Note safety net that has been installed on outside of trestle." Fresh batches of concrete were brought out from the batch plant in a ladle car, rolled south high on a trestle, dumped into one of the 12 buckets, and taken out and down by cableway to its destination. (Courtesy of Bureau of Reclamation, photo by A.E. Turner, P557-420-5369, 10-19-60.)

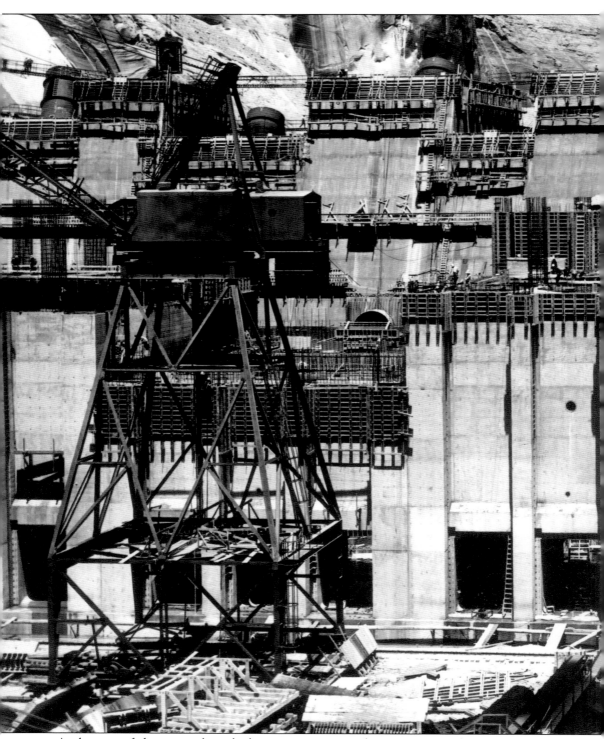

A close up of the powerplant, looking upstream, reveals its massive and intricate concrete construction. The dam structure behind it, not much taller at this point in time, would rise, in

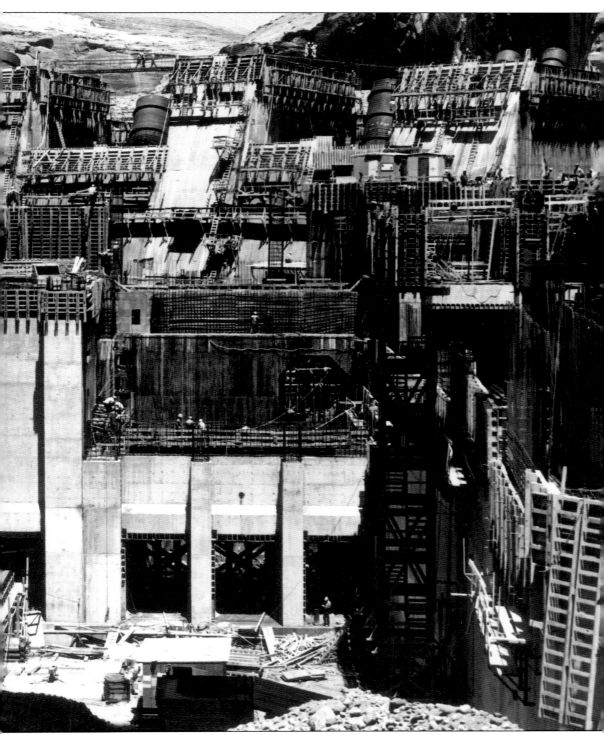
the next two years, hundreds of feet more and tower above the powerplant. (Courtesy of Bureau of Reclamation, July 1961.)

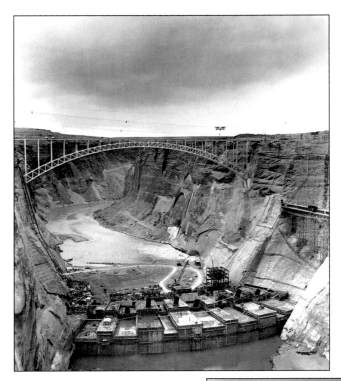

In this weekly progress photo looking downstream at the back of the dam, one of the 12-yard concrete buckets is being loaded from the ladle car on the transfer trestle. (Courtesy of Bureau of Reclamation, June 29, 1961.)

This progress photo was taken a month later than the one above and is a view looking upstream. All of the key elements can be identified: the two contiguous rows of dam blocks rising up, the powerplant under construction, the batch plant, the coffer dam, and the diversion tunnels. The concrete, which produced its own heat as it cured, had to be cooled, and this was accomplished by laying cooling pipes within the concrete that would then have cool water running through them. (Courtesy of Bureau of Reclamation, July 29, 1961.)

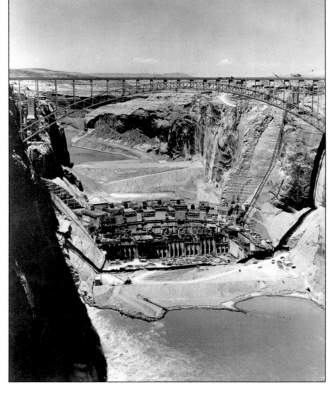

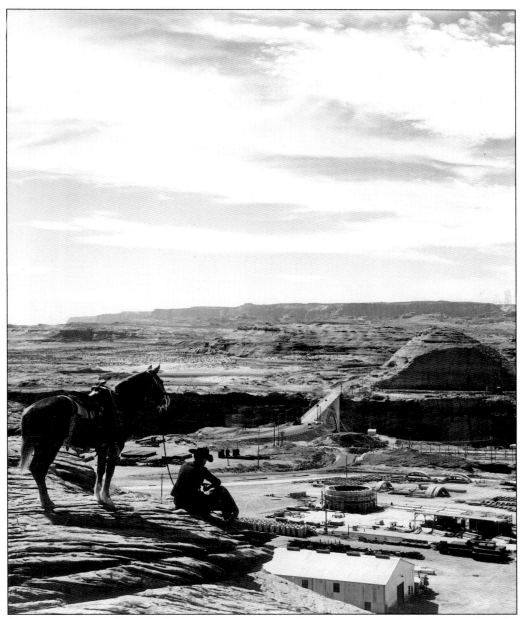

"A cowboy and his horse look down on a section of the huge construction base assembled by Merritt-Chapman & Scott Corporation to build Glen Canyon Dam on the Colorado River in Northern Arizona. The dam will benefit five Intermountain states—Arizona, Colorado, New Mexico, Utah and Wyoming—and will be the key unit in development of the Colorado River Storage Project." This photograph was entitled "The Old and New West Meet." (Courtesy of Bureau of Reclamation.)

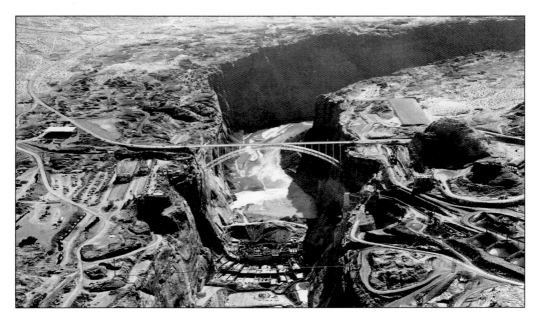

These two aerial views from upstream of Glen Canyon Dam under construction were taken looking south at the back side of the dam. Progress is discernable when comparing the image below to the one above, although the time of day each was taken adds to the difficulty in determining exactly what has changed and what has not. Below, the third and smaller 25-ton cableway is visible with its east and west head frame also in view. (Both courtesy of Bureau of Reclamation; above, late 1960; below, early 1961.)

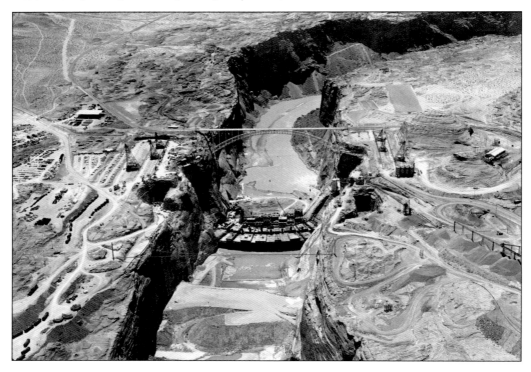

The powerplant, service bay, machine shop bay, river outlets, and tailrace area can be seen in this snowy December 18, 1961 photograph, looking down and to the east at the aforementioned areas under construction. The outlet works—four pipes, 96 feet in diameter, in the upper right corner—could release, when needed, a combined 15,000 cubic feet of water per second.

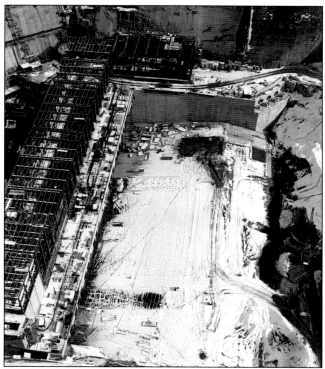

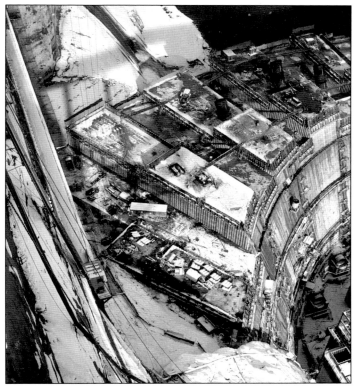

This December 18, 1961 photograph depicts blocks 15 to 23 on the right (west) side of the canyon. Penstock sections can be seen cast in place in the dam blocks on top as well as at the bottom where they come out of the dam and will be connected to more sections leading into the powerplant. At the center and far right, a 12-yard concrete bucket hangs from the almost vertical surface of one of the dam blocks, placed there like one would hang a coat on a hook.

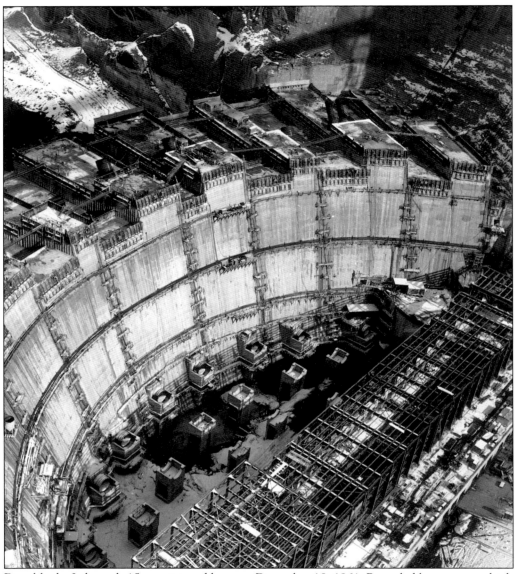
Dam blocks 3 through 15 are pictured here on December 18, 1961. Rounded bases upon which sections of penstock will be set appear to be ready to receive them, and structural steel for the powerplant has been erected. Curved horizontal "catwalks" can be seen against the downstream face of the dam. To gain perspective of how man stacks up against this dam there are ladders, seemingly very small ladders, that extend from one walkway to another.

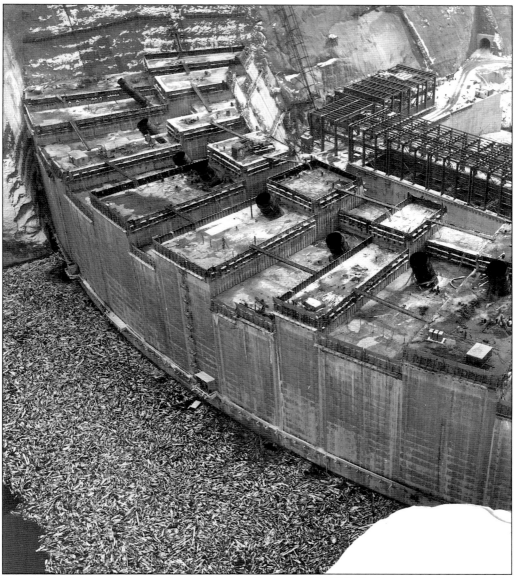

Dam blocks 4 through 16 were photographed on December 18, 1961. In the upper right corner, the canyon floor portal of the access tunnel can be seen. The horizontal lines on the dam blocks in this downstream view represent the $7\frac{1}{2}$-foot lifts of concrete pour at each block. Set in place atop each dam block are the steel forms readied for the next $7\frac{1}{2}$-foot lift of concrete to be poured.

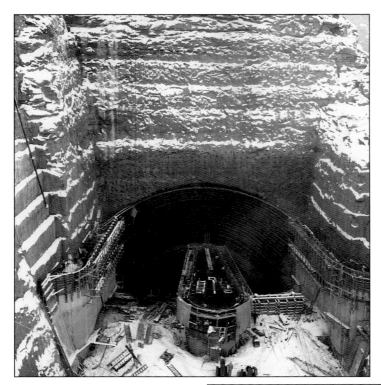

In this image, also taken on December 18, 1961, the left (east) spillway appears under construction, and graceful and curved formwork, at the center and on each side of the spillway entrance, is also being worked on. Above the spillway, numerous rock bolts have been installed to keep the sandstone from coming loose and falling.

Weekly progress photographs were taken throughout the placement of concrete on the dam structure. In this photograph, despite the fact that it was January and the dead of winter, there is a healthy discharge of water coming out of the right (west) diversion tunnel. (Courtesy of Bureau of Reclamation, photo by A.E. Turner, P-557-420-6629, 1-18-62.)

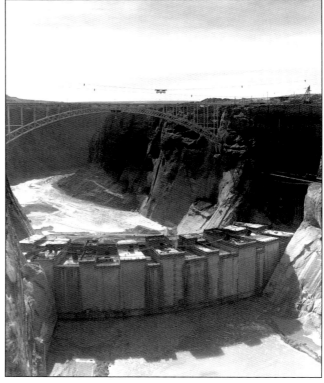

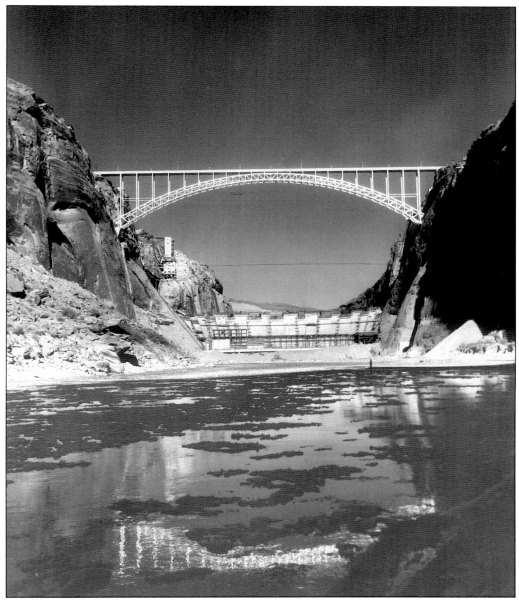
A shimmering reflection of Glen Canyon Bridge in the floating ice of the Colorado River warms this cold January day. Rapidly changing weather conditions, not unusual for the Four Corners Region, would have vastly changed this view from a downstream sandbar. (Courtesy of Bureau of Reclamation, photo by A.E. Turner, P-557-420-6632, 1-16-62.)

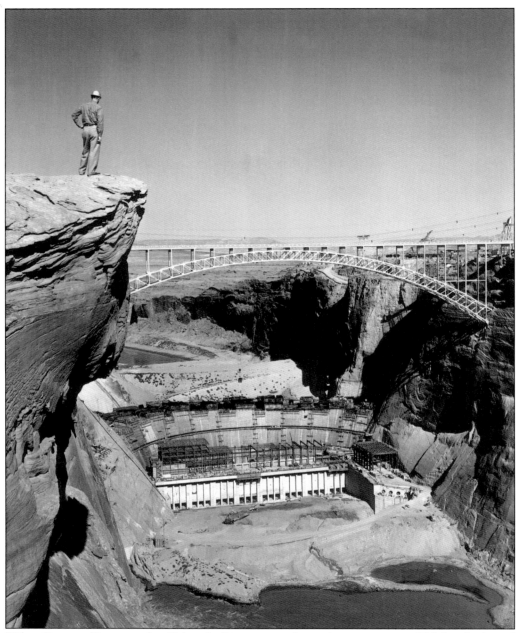

"Glen Canyon Dam, on the Colorado River in northern Arizona, is now 325 feet high and contains two million yards of concrete. When finished in early 1964, it will tower 710 feet high and will contain five million cubic yards of concrete. The workman at left is standing on a point approximately $1/2$ mile downstream from the dam. Structural steel is now being installed in the powerplant, located at the toe of the dam. Present schedules call for closure of the diversion tunnels and initial storage of water in January, 1964, at which time Lake Powell will begin to form." (Courtesy of Bureau of Reclamation, photo by F.S. Finch, 3-4-63.)

"Damsite (General): Looking over arch of Glen Canyon Dam toward the west side of canyon. River outlet tubes curve toward face of dam. Note also decreasing size of 'B' blocks compared with earlier photographs." (Courtesy of Bureau of Reclamation, photo by A.E. Turner, P-557-420-6654, 1-23-62.)

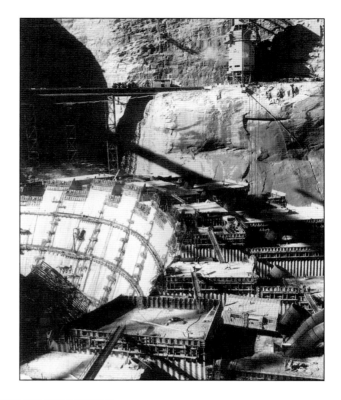

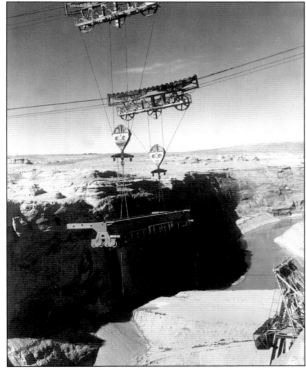

"A 44-ton section of powerplant crane is carried straight over the canyon prior to being dropped into position in the powerplant. Both of the 50-ton-capacity cableways were used for this operation because of the awkward length of the section." (Courtesy of Bureau of Reclamation, photo by W.L. Rusho, P-557-420-6679, 2-4-62.)

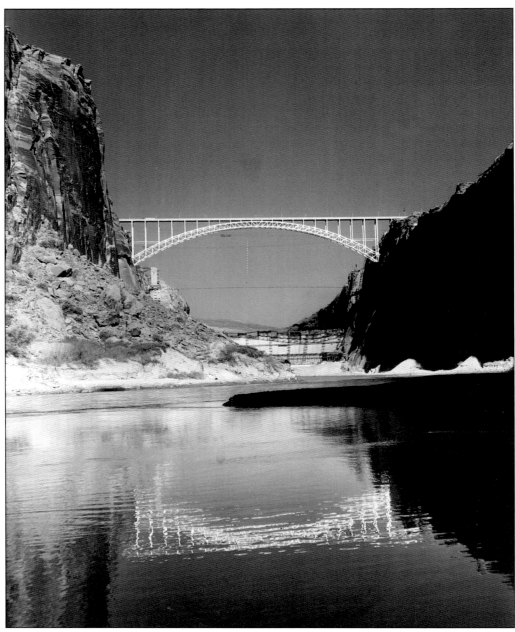

The slender and majestic arch of the Glen Canyon Bridge stands above the Colorado River while its image wavers in the water below. The following are some pertinent facts about Glen Canyon Bridge, which, at the time of its construction, was the highest steel arch bridge in the United States. Construction of the bridge, which cost $5 million, occurred between February 1957 and January 1959, and the prime contractor on the project was Kiewit-Judson & Pacific-Murphy. The bridge stands 700 feet above the Colorado River. The length of the deck is 1,271 feet, the width of the deck is 38 feet, and the width of the roadway 30 feet. The arch spans 1,028 feet with a vertical rise in the arch of 165 feet. A total of 4,000 tons of steel was used in the structure. (Courtesy of Bureau of Reclamation, photo by A.E. Turner, P-557-420-6683, 2-1-62.)

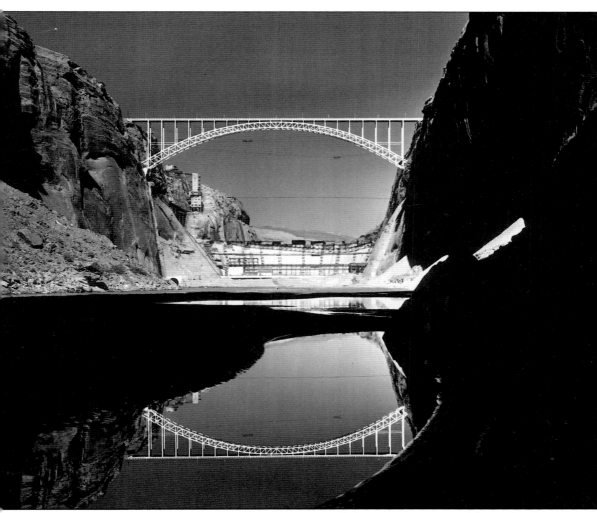

Glen Canyon Bridge is mirrored in the calm and very still downstream waters of the Colorado River. The image in the water forms the bottom frame of a vignette of Glen Canyon Dam under construction. Faintly visible in the background, a bucket of precisely mixed concrete is lowered from the cableway to one of the dam blocks. Cables that were normally stretched taut across Glen Canyon are pulled down by the weight of the concrete. (Courtesy of Bureau of Reclamation, photo by A.E. Turner, P-557-420-6681, 2-1-62.)

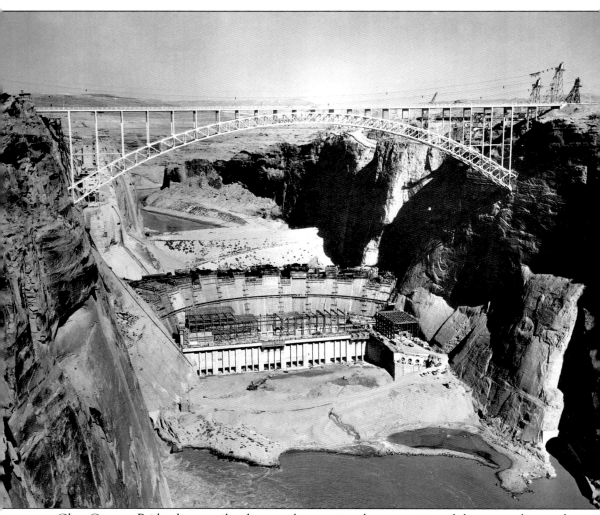

Glen Canyon Bridge hovers silently over the continued construction of the powerplant and dam. Turbulent water comes out of the discharge end of the right (west) diversion tunnel, the lower of the two tunnels. To the right of the rushing waters is an eddy formed against a protective coffer dam. Only back waters are present at the left (east) diversion tunnel. Three head frames are visible on the left (east) canyon rim, one for each of the two 50-ton cableways and one for the smaller 25-ton unit. (Courtesy of Bureau of Reclamation, photo by A.E. Turner, P-557-420-6681, 2-1-62.)

On the backside of the dam, at dam Block 6, workmen install supports for trashrack formwork. Each of the eight penstock water intakes would have a trashrack structure built over it so that only water could enter the penstock tube on its way to the electric generating turbines in the powerplant. (Courtesy of Bureau of Reclamation, photo by A.E. Turner, P-557-420-6741, 2-8-62.)

"Powerplant: Concrete placement proceeds on the tailrace slab downstream from the powerplant. Straw, wooden housing, and portable heaters are used to keep the concrete warm." While the concrete in the dam blocks had to be cooled as it cured, these pours necessitated protection from the cold, an equally damaging condition on pours of far less mass. (Courtesy of Bureau of Reclamation, photo W.L. Rusho, P-557-420-6621, 1-15-62.)

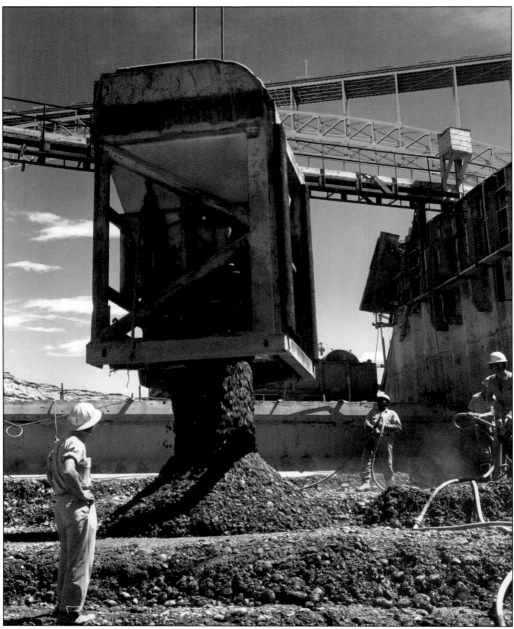

"One of the largest construction plants in history was assembled by Merritt-Chapman & Scott at Glen Canyon to build dam and hydro-electric power facility. Concrete is mixed in a huge batching plant standing on a ledge hewn out of [the west] canyon wall just above the dam. From the batching plant, concrete is carried via electric trains and dumped into outsized buckets. Then later they are hauled via cableway to the dam where workers, some of them Navajo Indians from the nearby reservation, vibrate it into place." (Text courtesy of *Black Horse News*, winter 1963–1964; photo used by *Black Horse News*, courtesy of Bureau of Reclamation, photo by A.E. Turner, P-557-420-7014, 5-11-62.)

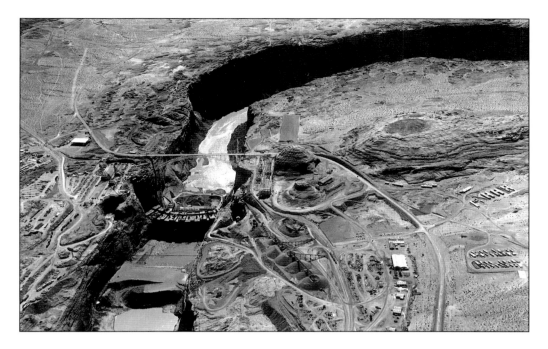

In these opposing progress photographs, one taken from downstream and the other from upstream, the dam blocks appear to be roughly one-third of the way up to the canyon rim. It has been 18 months since the nonstop placement of concrete for the dam began, and it will be another 17 months before the last bucket is placed. (Courtesy of Bureau of Reclamation, photo by A.E. Turner, P-577-420-6758, 2-23-62.)

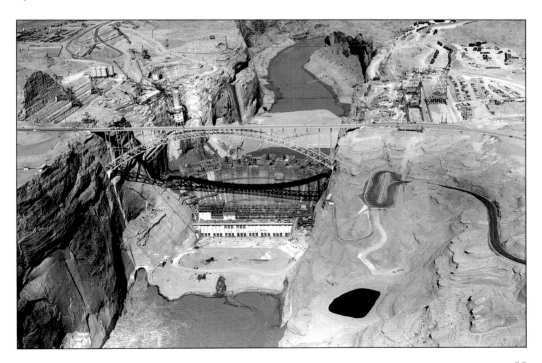

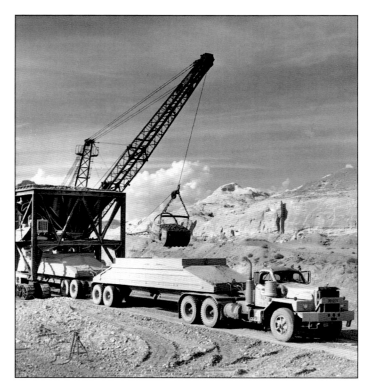

"Ten million tons of aggregate must be hauled for the more than 5 million cubic yards of concrete needed to harness the mighty Colorado. Merritt-Chapman & Scott, general contractor for the Glen Canyon Dam project, is using Mack B-80's for the critical hauling job. Round trip from the aggregate source to batching plant stockpile is a grueling 11 miles. Hauling 200,000 lbs. G.C.W., the Macks make this run in a remarkable 21 minutes!" (Text courtesy of Mack Truck advertisement in *Engineering Record News*, May 1963; photo courtesy of Interstate Photographers, J-2049, 6-4-63.)

"Hauling 200,000 lbs. G.C.W., this Mack tractor easily pulls trailer train loaded with aggregate up steep grade from loading tunnel. Special gearing permits speeds up to 55 mph on the 11 mile run." (Text courtesy of Mack Truck advertisement in *Engineering Record News*, May 1963; photo courtesy of Interstate Photographers, J-2032, 6-4-63.)

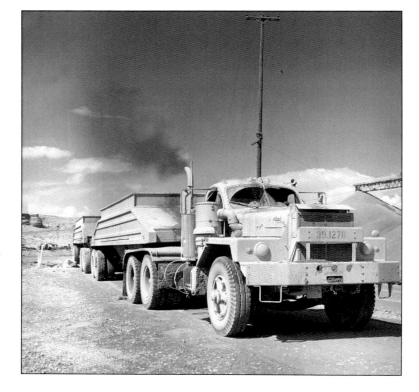

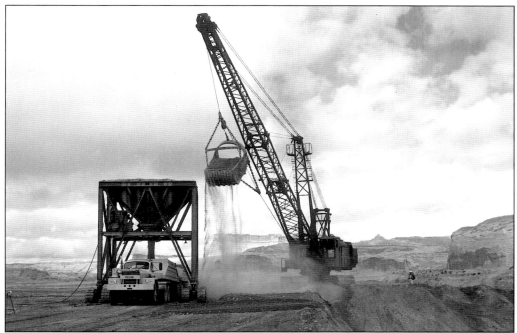

"View of dragline about to empty a bucket load of raw material into the truck loading hopper, Area A, while the front trailer of a two-trailer truck unit is being loaded from the hopper." (Courtesy of Bureau of Reclamation, photo by A.E. Turner, P-557-420-6771, 2-20-62.)

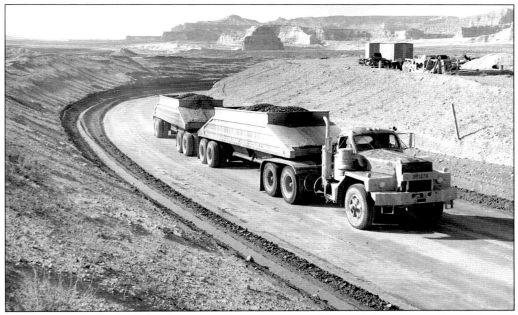

"To attain maximum hauling capacity from each unit, Merritt-Chapman & Scott hitched two large volume belly-dump trailers to specially designed Mack tractors." (Text courtesy of Mack Truck advertisement in *Engineering Record News*, May 1963; photo courtesy of Interstate Photographers, J-2023 6-4-63.)

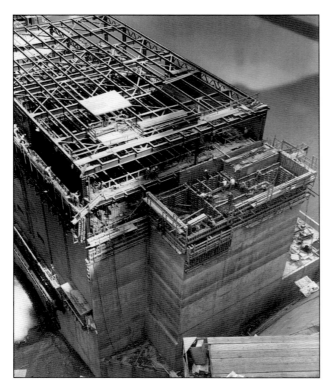

The structural steel for the roof structure at the west end of the powerplant is nearly complete and metal roof decking installation has begun. Lightweight concrete will be poured over the metal roof decking. (Courtesy of Bureau of Reclamation, photo by A.E. Turner, P-557-420-7006, 5-10-62.)

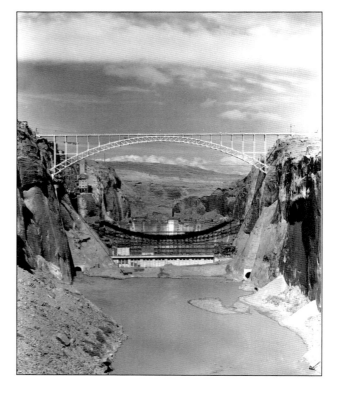

An unusual vantage point was used in taking this photograph. It was shot looking out of Adit 8, one of the fresh-air holes made in the canyon wall along the two-mile powerplant access tunnel. (Courtesy of Bureau of Reclamation, photo by A.E. Turner, P-557-420-6726, 2-13-62.)

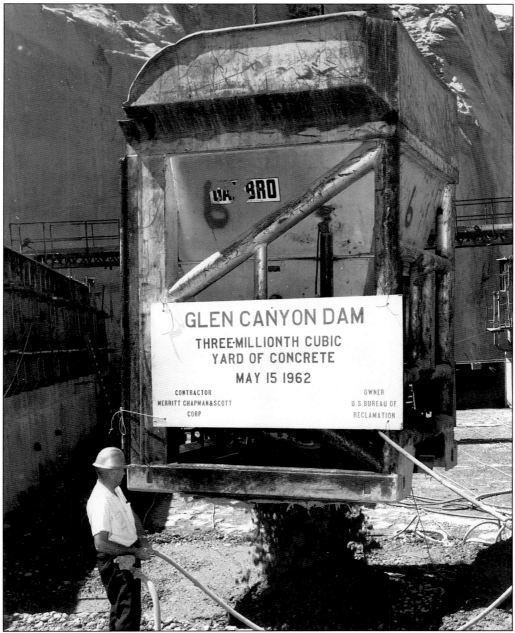

"The bucket containing the three millionth cubic yard of concrete to be placed in Glen Canyon Dam is dumped by L.R. Wylie, Project Construction Engineer for the Bureau of Reclamation. When the dam is finished in early 1964, it will contain approximately five million cubic yards of concrete and will rise 710 feet above bedrock. The dam is now 437 feet high. The contractor, Merritt-Chapman & Scott Corporation, is using 12-cubic-yard buckets to place concrete at a rate of over 8,000 cubic yards a day. The crews work three shifts a day, five days a week." (Courtesy of Bureau of Reclamation, photo by A.E. Turner, P-557-420-6994, 5-15-62.)

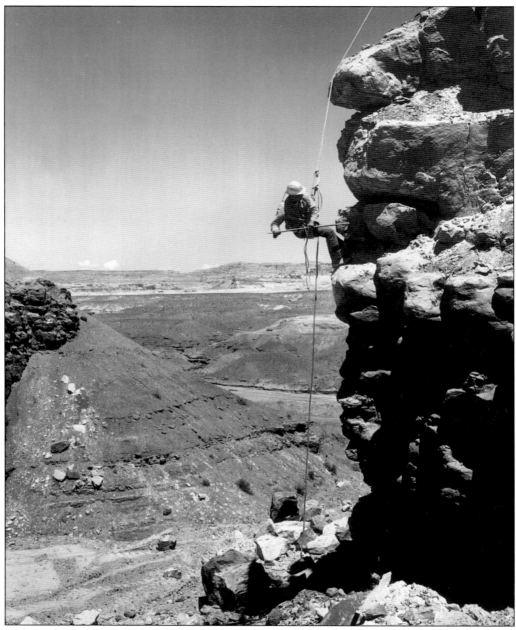
Making the work area below safe, a highscaler pries loose rock off the side of a cliff during the construction of an access road to Wahweap. (Courtesy of Bureau of Reclamation, photo by A.E. Turner, P-557-420-7055, 5-18-62.)

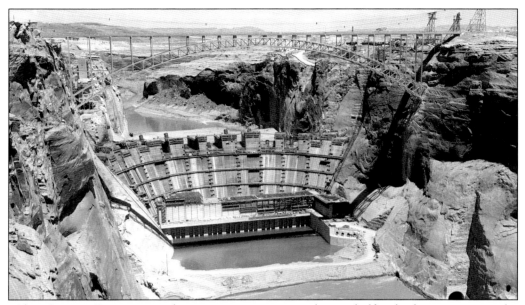

"Glen Canyon Dam as seen from a point approximately one half mile downstream on the rim of the canyon. The dam now contains three million out of an eventual five million cubic yards of concrete. It is 437 feet high and when finished will be 710 feet height. The three millionth cubic yard of concrete was placed May 15, 1962, by L.R. Wylie, Project Construction Engineer for the Bureau of Reclamation. Concrete is now being placed in the dam at the rate of approximately 8,000 cubic yards a day." (Courtesy of Bureau of Reclamation, photo by A.E. Turner, P-557-420-6986, 5-15-62.)

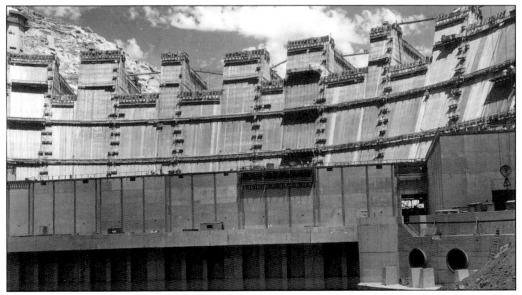

Despite the work being far from complete, this photograph depicts a dam and powerplant that hardly appear to be under construction. Very visible on the front, downstream side of the dam is the ladder and "catwalk" system. (Courtesy of Bureau of Reclamation, photo by F.S. Finch, P-557-420-7211, 7-5-62.)

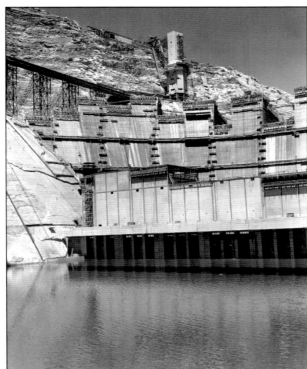

This photograph shows several elements. Working down from the canyon wall, which was formed by and carries the river, is the concrete batch plant and trestle system used to deliver the concrete. Below that is the dam, the result of the placement of large amounts of concrete from the batch plant. The powerplant below and in front of the dam will produce power when the river is allowed to pass through to the other side. (Courtesy of Bureau of Reclamation, photo by A.E. Turner, P-557-420-7107, 5-31-62.)

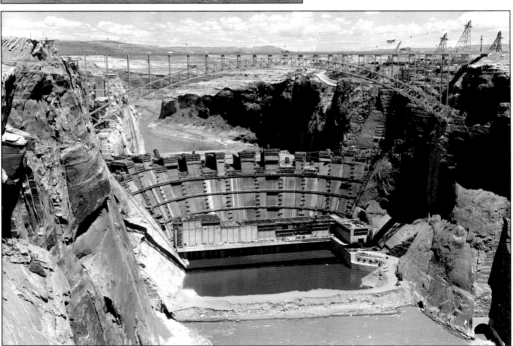

A weekly progress photo looks upstream at the face of the dam. More than three million yards of concrete has been poured and four million is now in the dam-builders' sights. (Courtesy of Bureau of Reclamation, photo by A.E. Turner, P-557-420-7106, 5-31-62.)

"Framed by the steel work of the powerplant, a huge 15-foot diameter penstock section moves slowly toward the unloading dock." (Courtesy of Bureau of Reclamation, photo by A.E. Turner, P-557-420-7139, 6-6-62.)

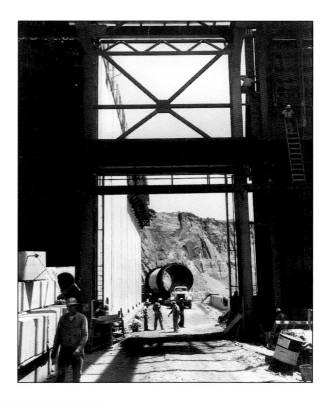

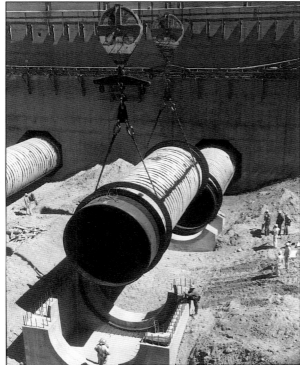

"Two highlines are used in tandem to carry penstock section to its position between the dam and powerplant." (Courtesy of Bureau of Reclamation, photo by A.E. Turner, P-557-420-7148, 6-6-62.)

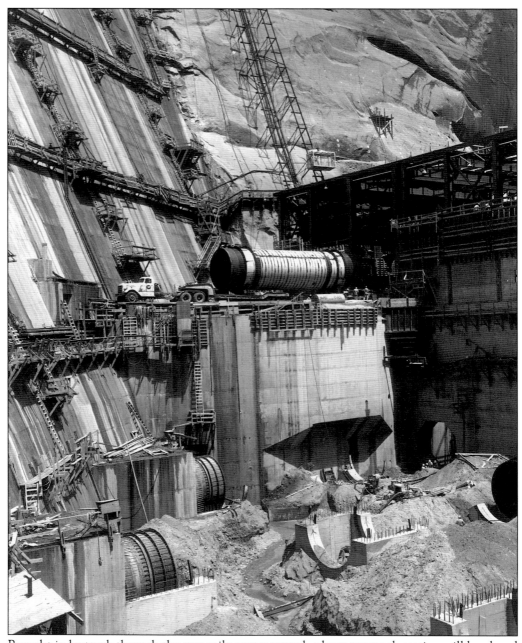
Brought in by truck through the two-mile access tunnel, a huge penstock section will be placed onto the loading dock where highlines from the two cableway systems will lift and place it into position. (Courtesy of Bureau of Reclamation, photo by A.E. Turner, P-557-420-7141, 6-6-62.)

Taken from the "chickenwire" footbridge, this view of the back side of the dam looks more like an intricately dovetailed piece of woodwork rather than the rising blocks of concrete that it is. (Courtesy of Bureau of Reclamation, photo by A.E. Turner, P-557-420-7151, 6-21-62.)

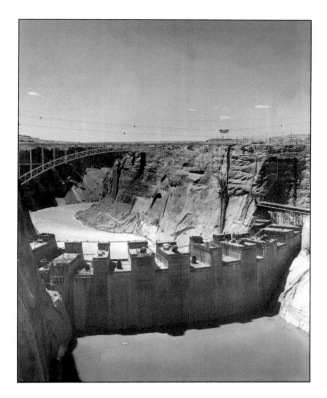

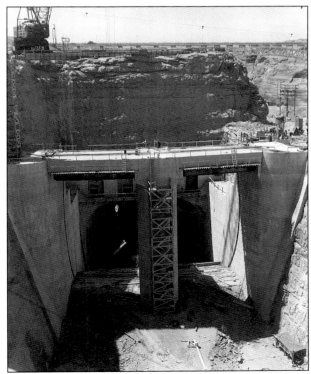

Nearing completion is the concrete structure for the east (left) spillway. Somewhere between here and the canyon bottom it connects with the east (left) diversion tunnel. They each serve a relatively common purpose —to divert water downstream, one during construction and one after. (Courtesy of Bureau of Reclamation, photo by A.E. Turner, P-557-420-7189, 6-28-62.)

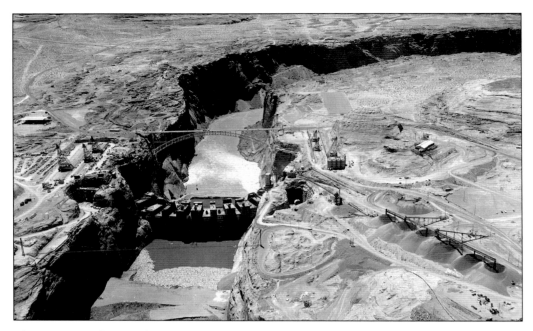

These two aerial views show progress on the construction of Glen Canyon Dam. In the upper view looking downstream, the concrete batch plant operation is extensive. Stockpiled materials and conveyors are lined up as the various materials are moved to the actual batch plant on a shelf below the canyon rim. Both diversion tunnels are discharging water as seen in the lower photo. The right (west) tunnel appears to be at or near capacity, the left (east) tunnel discharging what the right tunnel cannot. (Courtesy of Bureau of Reclamation, photos by A.E. Turner, P-557-420-7168 and P-557-420-7170, both 6-18-62.)

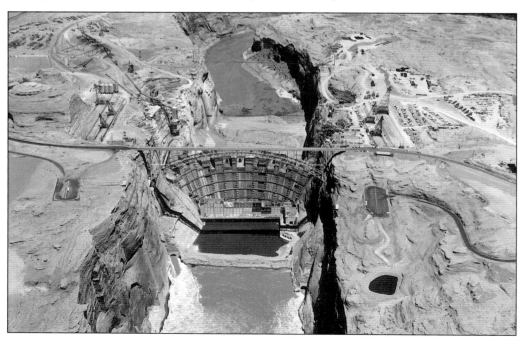

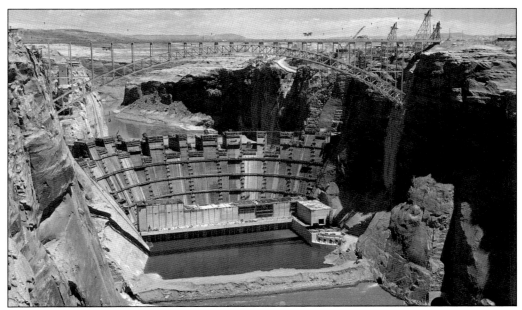

This weekly progress photograph was taken from the often frequented "Photo Point No. 1," located downstream on the west side of the Glen Canyon. (Courtesy Bureau of Reclamation, photo by A.E. Turner, P-557-420-7152, 6-21-62.)

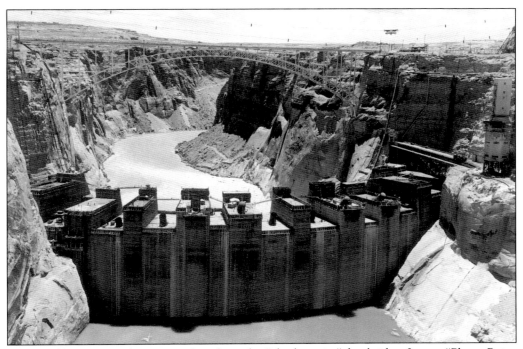

This weekly progress photo was taken from the "chickenwire" footbridge. Just as "Photo Point No. 1" was used to record progress looking upstream, this was the location of choice looking downstream and at the back side of the dam. (Courtesy of Bureau of Reclamation, photo by F.S. Finch, P-557420-7209, 7-5-62.)

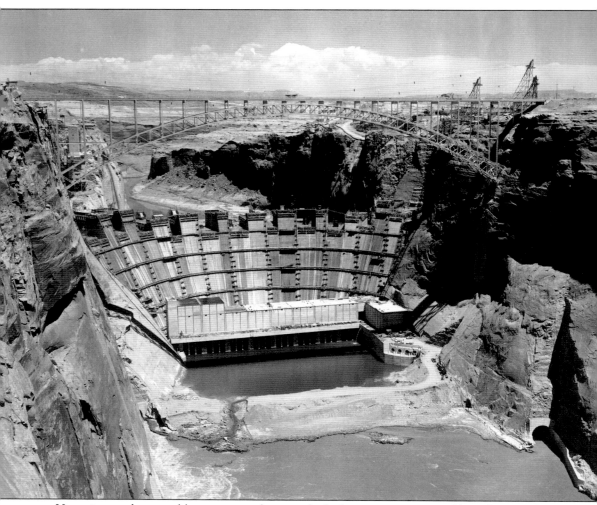

Here is another weekly progress photograph looking upstream at Glen Canyon Dam. Each progress photo depicts subtle changes, but some show changes that are distinct and profound. Compared to a June 18, 1962 progress photograph, this image tells a lot about the spring runoff of 1962. Discharges at the diversion tunnels have slowed, when only a month or so prior there was a swift outflow. (Courtesy of Bureau of Reclamation, photo by A.E. Turner, P-557-420-7359, 7-26-62.)

"Glen Canyon Powerplant: Upstream side of Glen Canyon powerplant looking toward east side." An excellent view of the penstock tubes coming out of the dam structure and leading into the powerplant. To the right of the dam is the lower end of one of the monkey slides. Roofing operations at the powerplant progress. (Courtesy of Bureau of Reclamation, photo by A.E. Turner, P-557-420-7361, 7-27-62.)

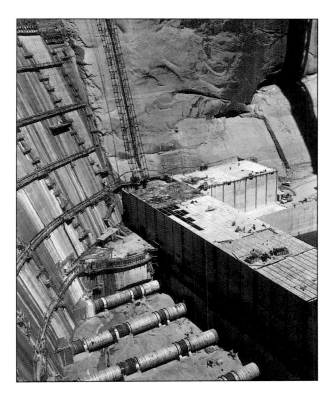

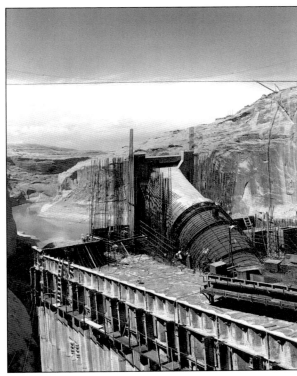

"Penstocks: Forms and reinforcement steel for the penstock transition concrete and trashracks are being installed in Block 16 on Penstock 2." (Courtesy of Bureau of Reclamation, photo by A.E. Turner, P-557-420-7364, 7-27-62.)

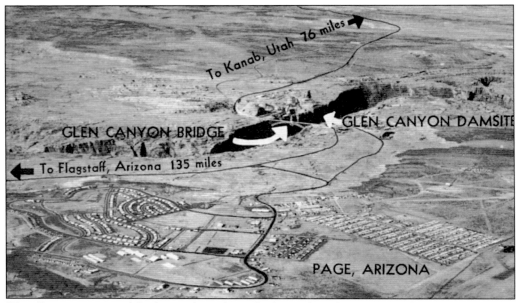

"Excellent, new, paved highways have been built to the Glen Canyon damsite. A 76 mile highway through the highly scenic area has been built from Kanab, Utah, to the damsite. A new 25 mile highway extends northward from Bitter Springs, Arizona to the damsite. Both of these highway links connect with the Glen Canyon Bridge to form a new link in U.S. Highway 89." (Courtesy of Bureau of Reclamation, Glen Canyon Dam brochure issued 1963.)

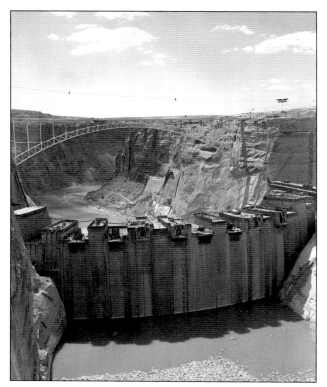

"The rising blocks of Glen Canyon Dam as seen from the footbridge looking downstream. The openings for the eight 15-foot-diameter penstocks can be seen near the top of the existing structure. The highest point of the dam is now 520 feet above bedrock. When finished, the dam will be 710 feet high." (Courtesy of Bureau of Reclamation, photo by A.E. Turner, P-557-420-7429, 9-13-62.)

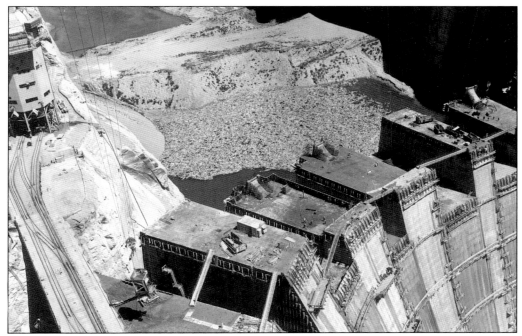

Concrete was placed in the dam blocks under the transfer trestle by use of a chute. The concrete bucket was attached to a hopper with a chute for these pours. Although no water had yet been allowed to back up behind the dam, the erratic flow of the river did sometimes send water behind the coffer dam and with it, an ample amount of driftwood. (Courtesy of Bureau of Reclamation, photo by F.S. Finch, P-557-420-7380, 8-10-62.)

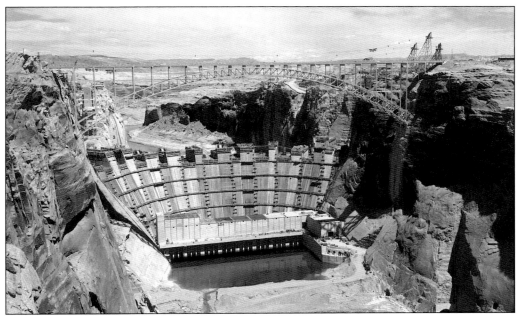

This weekly progress photo was taken from a point a half mile downstream—"Photo Point No. 1". (Courtesy of Bureau of Reclamation, photo by F.S. Finch, P-557-420-7376, 8-9-62.)

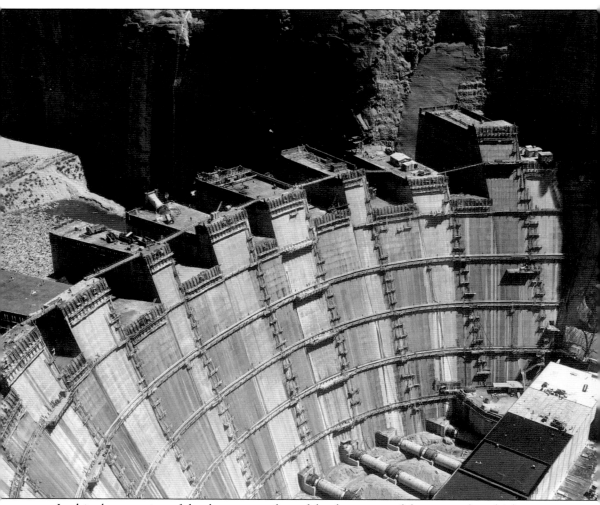

In this close-up view of the downstream face of the dam, some of the penstocks, which measure 15 feet in diameter, can be seen where they leave the dam and extend into the powerplant. From where the water enters the penstock on the upstream side of the dam it descends 400 feet at a 60 degree angle. Up to 1.3 million gallons of water can be put into each of the power turbines every minute. The powerplant, when completed in 1966, consisted of four 118,750-kilowatt and four 136,563-kilowatt generators capable of producing 1,320,000 kilowatts of power. (Courtesy of Bureau of Reclamation, photo by F.S. Finch, P-557-420-7381, 8-10-62.)

"Interior of plug section of right [west] diversion tunnel. Concrete is being placed via pumpcrete pipe on scaffold." (Courtesy of Bureau of Reclamation, photo by A.E. Turner, P-557-420-7458, 9-12-62.)

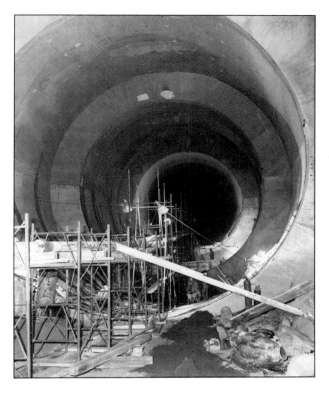

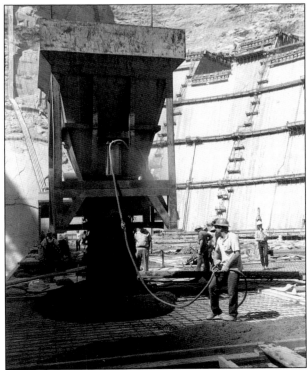

A bucket of lightweight concrete is placed from the concrete bucket onto the powerplant roof. Lightweight concrete is a mix design that uses a pumice-like aggregate to give the concrete a lighter weight. It is not uncommon for it to be used on roof structures. (Courtesy of Bureau of Reclamation, photo by A.E. Turner, P-557-420-7419, 8-27-62.)

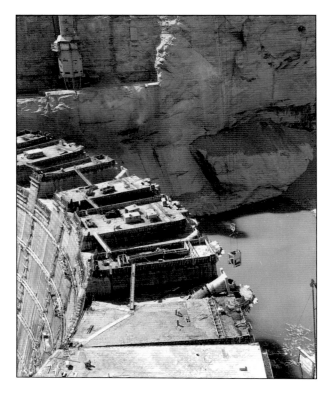

"A twelve cubic yard concrete bucket is shown at right having just delivered 24 tons of concrete to a block of the dam. The bucket is being returned to the loading dock to be refilled. The concrete batching plant is shown at top left. The large pipes imbedded in the blocks of the dam are 15-foot-diameter penstocks which will carry water through the dam to drive the turbines and generators." (Courtesy of Bureau of Reclamation, photo by A.E. Turner, P-557-420-7465, 9-14-62.)

"Penstocks between dam and powerplant showing various stages of construction of coupling housing. At bottom of photo is completed unit. Others exhibit various stages of construction." (Courtesy of Bureau of Reclamation, photo by A.E. Turner, P-557-420-7464, 9-14-62.)

On the upstream face of the dam, formwork to pour concrete around the penstock intakes is under construction. Visible on the upper right are monkey slides, a form of vertical transportation used to move workmen from canyon rim to canyon floor and back again with a minimal amount of time and effort. (Bureau of Reclamation, photo by A.E. Turner, P-557-420-7493, 9-24-62.)

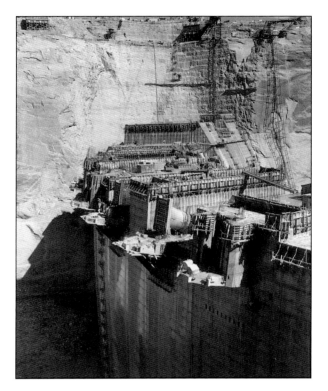

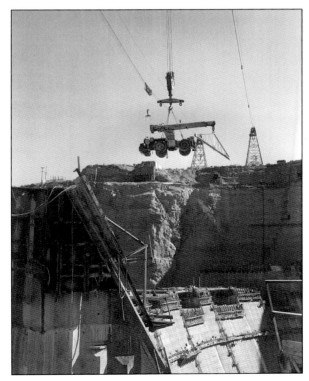

An Austin-Western Hydro-Crane is transported over the Glen Canyon Dam site to a new location atop the rising dam where it will be lowered and set up on blocks. Its primary purpose was to lift the large, heavy concrete forms. (Courtesy of Bureau of Reclamation, photo by A.E. Turner, P-557-420-7492, 9-25-62.)

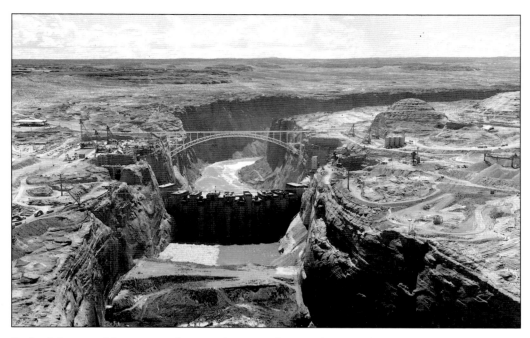

Both of these weekly progress photographs were taken on the same day and looking downstream, but they were taken from different angles. The dam appears to be three-quarters complete, which means about 3,700,000 yards of concrete have been poured. (Courtesy of Bureau of Reclamation, photos by A.E. Turner, P-557-420-7504 and P-557-423-7503 both 9-25-62.)

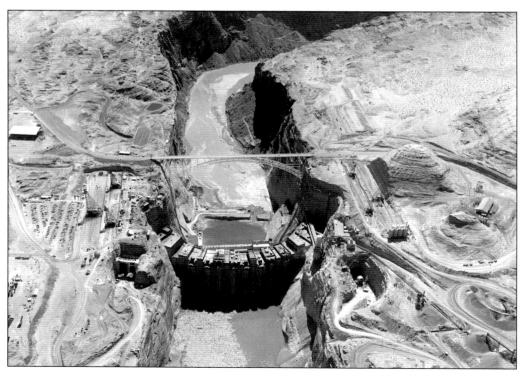

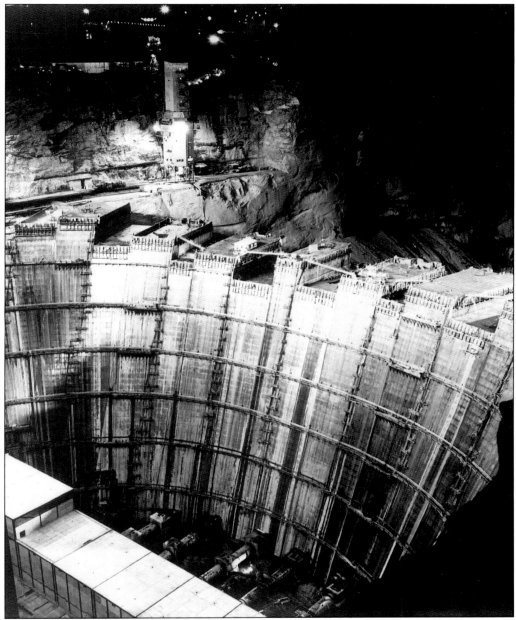
At night the work did not stop, but photographs taken at night are rare. This view of the downstream face of Glen Canyon Dam was taken from the east rim under Glen Canyon Bridge. (Courtesy of Bureau of Reclamation, photo by A.E. Turner, P-557-420-7580, 10-24-62.)

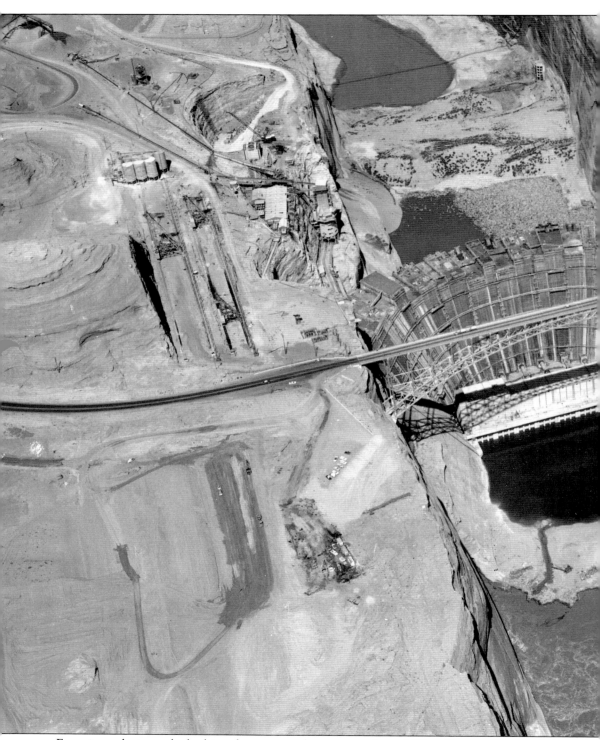
Even in a photograph, looking down upon the construction of Glen Canyon Dam and the completed Glen Canyon Bridge is a dizzying sight. (Courtesy of Bureau of Reclamation, photo

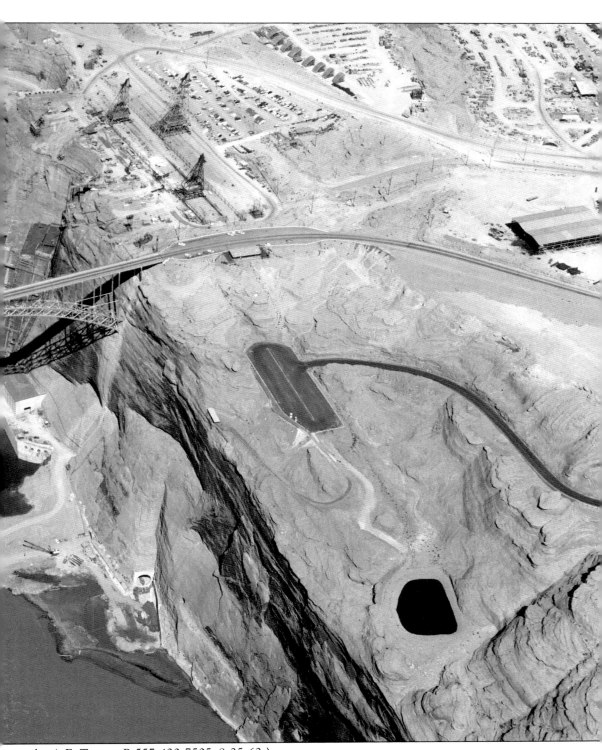
by A.E. Turner, P-557-420-7505, 9-25-62.)

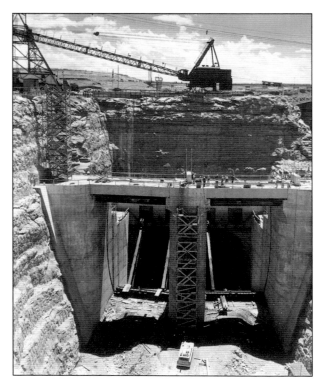

Radial gates to control the flow of water that goes through the spillway are being installed. (Courtesy of Bureau of Reclamation, photo by A.E. Turner, P-557-420-7515, 9-26-62.)

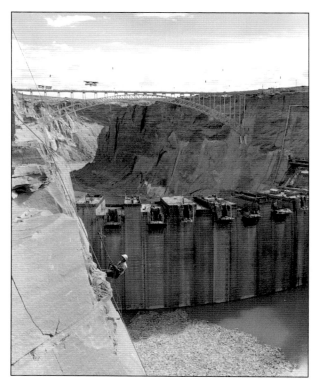

A highscaler climbs up the face of a cliff with Glen Canyon Dam and Bridge as a backdrop. (Courtesy of Bureau of Reclamation, photo by A.E. Turner, P-557-420-7518, 9-26-62.)

This view shows the upper portal of the left (east) spillway while construction is underway on the hoist bridge and gate structures. (Courtesy of Bureau of Reclamation, photo by A.E. Turner, P-557-420-7213, 7-5-62.)

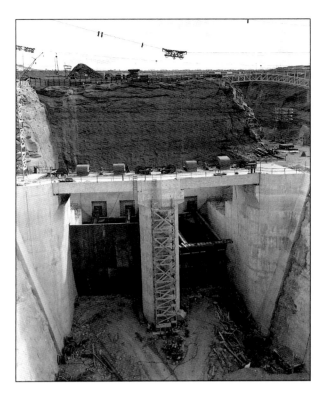

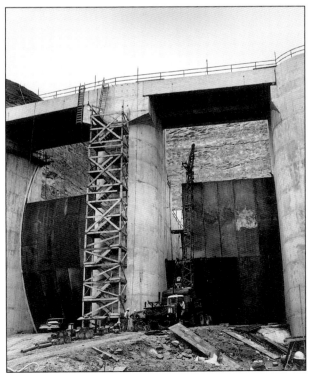

Here is a different perspective of the erection of radial gates at the upper portal of left (east) spillway. (Courtesy of Bureau of Reclamation, photo by A.E. Turner, P-557-420-7574, 10-15-62.)

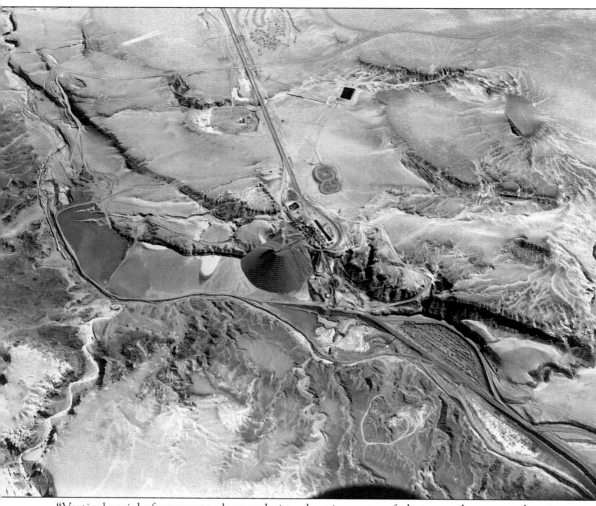

"Vertical aerial of aggregate plant and pits, plant in center of photo, road at top to damsite. Road to Crossing of the Fathers at upper left of photo." This unusually named area was located around Wahweap Creek. (Courtesy of Bureau of Reclamation, photo by A.E. Turner, P-557-420-7526, 10-3-62.)

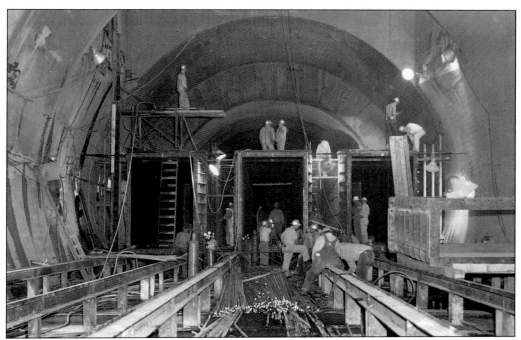

"Interior of left [east] diversion tunnel plug section showing installation of gate valve conduits." (Courtesy of Bureau of Reclamation, photo by A.E. Turner, P-557-420-7564, 10-10-62.)

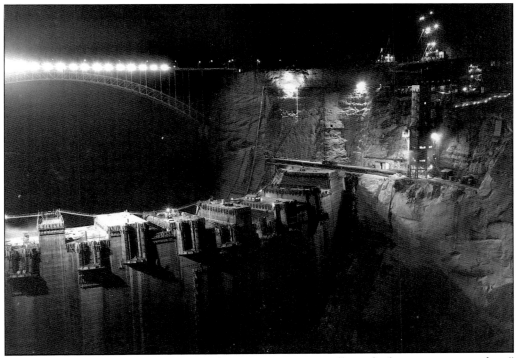

"Night view of Glen Canyon Damsite from east rim, near spillway, looking at upstream face." (Courtesy of Bureau of Reclamation, photo by A.E. Turner, P-557-420-7579, 10-24-62.)

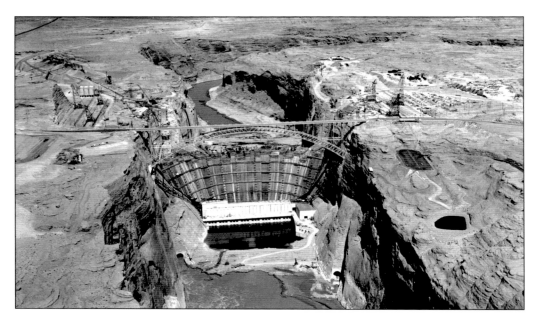

"The rising blocks of Glen Canyon Dam are seen looking north at the downstream side of the dam in an aerial view, and then looking from a point on the rim of the canyon just downstream. The highest block is now 565 feet above bedrock and the dam contains almost 4 million cubic yards of concrete. Closure of the diversion tunnel and initial storage of water in the reservoir, Lake Powell, is scheduled for next January. The construction crews of the prime contractor, Merritt-Chapman & Scott Corporation, are now placing concrete at the rate of 8,000 cubic yards a day. Work continues on an around-the-clock basis 5 days a week. Work is also under way on the installation of the turbines in the Glen Canyon Powerplant. The first generator is expected to go on the line soon after the dam is 'topped out' in 1964. The final generator will go on the line about February, 1966." (Both courtesy of Bureau of Reclamation, photo below by A.E. Turner, P-557-420-7594, 11-15-62.)

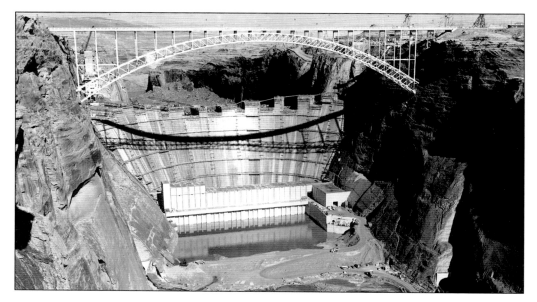

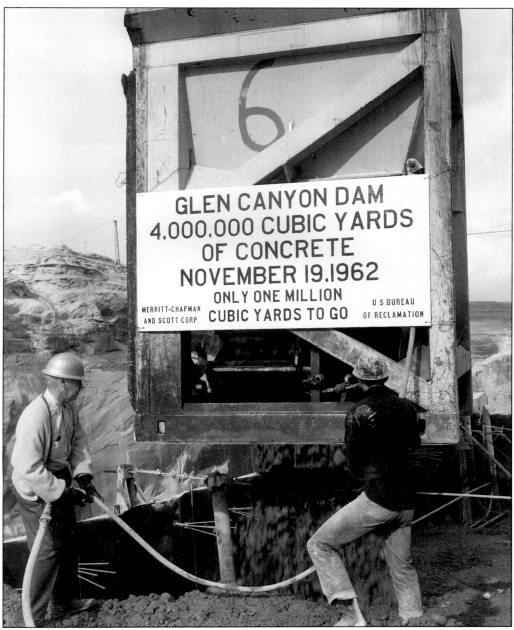

"Four Millionth Cubic Yard Placed In Glen Canyon Dam. On Monday, November 19th, the four millionth cubic yard of concrete was placed in Glen Canyon Dam by L.F. Wylie, Project Construction Engineer of the Bureau of Reclamation. This leaves only about one million cubic yards left to be placed. The giant structure, now rising 565 feet above bedrock, will eventually be 710 feet high, making it second only to Hoover Dam as the highest in the Western Hemisphere." Pictured here are L.F. Wylie, left, and Gary Dial, concrete foreman, right. (Courtesy of Bureau of Reclamation, photo by A.E. Turner, P-557-420-7596, 11-19-62.)

"Looking upstream in plug section of left [east] diversion tunnel. Hydraulic hoist lies on blocks in foreground. Other hoists can be seen in hoist chamber at top of photo." (Courtesy of Bureau of Reclamation, photo by A.E. Turner, P-557-420-7610, 11-14-62.)

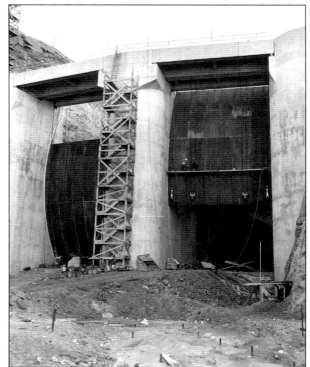

Welding is being done on the radial gates at the upper portal of the left (east) spillway. (Courtesy of Bureau of Reclamation, photo by F.S. Finch, P-557-420-7614, 11-21-62.)

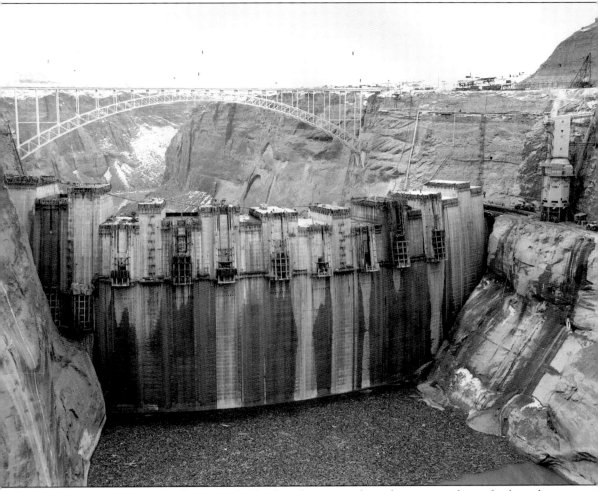

In this view from the "chickenwire" footbridge, the penstock trash grating is being built and installed at each of the penstock intakes. Water storage has not begun yet, but the sometimes capricious and changing flow of water at the diversion tunnels has brought in yet more driftwood that collects and floats behind the rising dam structure. Snow is visible on the dam blocks and on the canyon walls beyond the dam just before the bend. (Courtesy of Bureau of Reclamation, photo by A.E. Turner, P-557-420-7699, 1-3-63.)

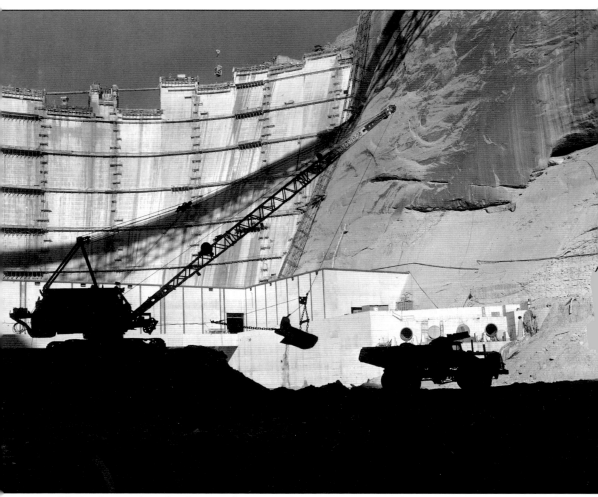

"A dragline and truck silhouetted against Glen Canyon Dam and powerplant are excavating the lower cofferdam, which material is then taken to the area between the dam and powerplant for backfill." Suspended from the cableway, a bucket of concrete is lowered to one of the dam blocks. There were just 12 such buckets used during the concrete placement portion of the project. One of the buckets, bucket #6, was retained and is on display at the Carl Hayden Visitor Center. (Courtesy of Bureau of Reclamation, photo by A.E. Turner, P-557-420-7771, 1-15-63.)

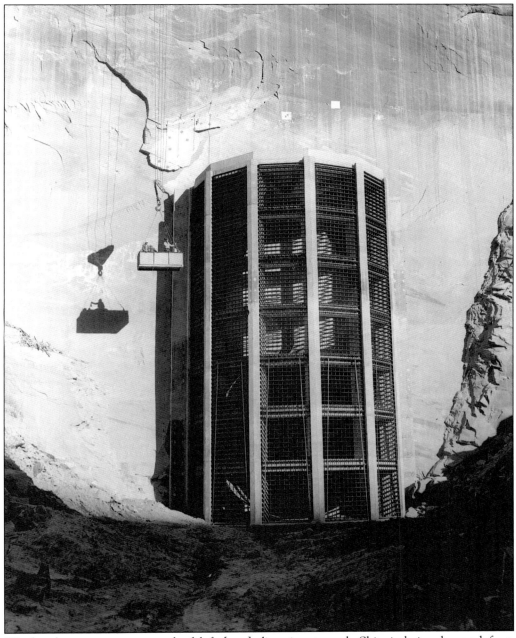

"Trashracks at upstream portal of left [east] diversion tunnel. Skip is being lowered from stiff leg on cliff above." (Courtesy of Bureau of Reclamation, photo by A.E. Turner, P-557-420-7804, 1-22-63.)

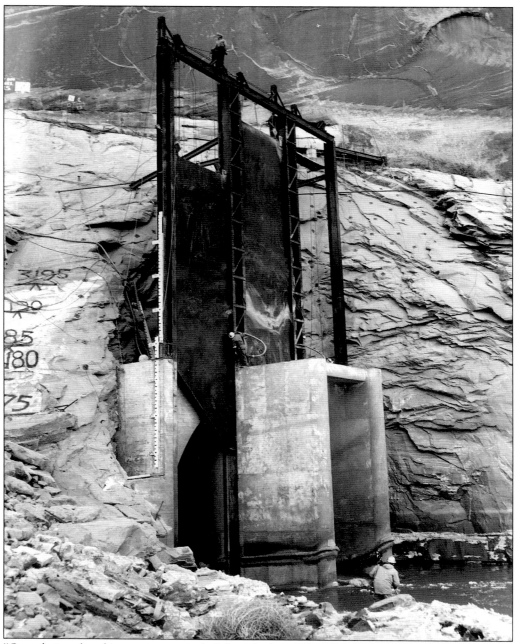

"Gates being closed in upstream portal of the right [west] diversion tunnel. Gates are being closed to enable contractor to plug tunnel." It was planned and indeed, on January 21, 1963, the flow of water into the diversion tunnel was stopped and the process of permanently plugging the tunnel began. (Courtesy of Bureau of Reclamation, photo by A.E. Turner, P-557-420-7813, 1-21-63.)

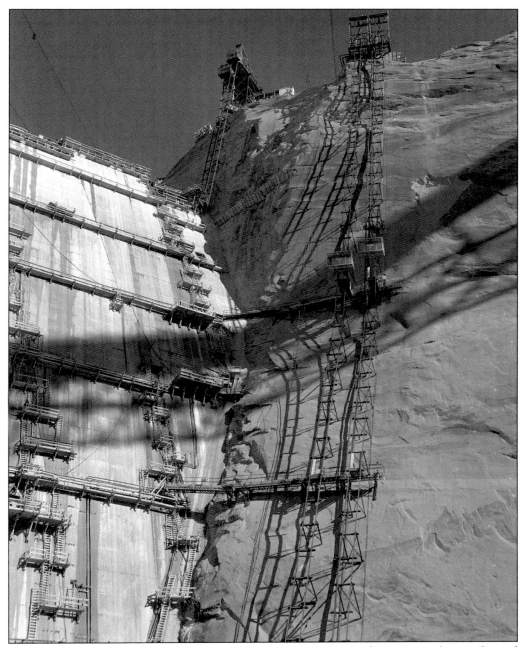
Vertical transportation from the canyon rim down to various levels of ongoing work was achieved using monkey slides. There were a total of six metal-cage, elevator-like units. Gliding, but fixed on rails, the cages were lowered and raised by cable connected to a hoist above. (Courtesy of Bureau of Reclamation, photo by A.E. Turner, P-557-420-7827, 1-22-63.)

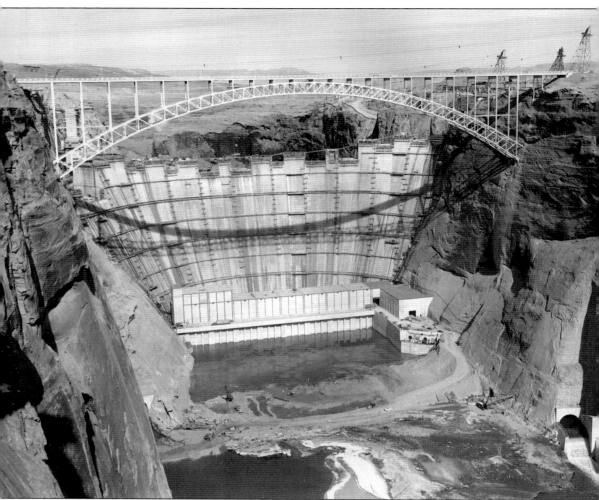

"Downstream side of Glen Canyon Dam and Powerplant as seen from Photo Point No. 1 approximately one half mile downstream on west rim. Note water flow from left diversion tunnel." Just days earlier, the water flow was stopped from entering the right (west) diversion tunnel, causing the river to begin backing up. Built 33 feet higher than the right diversion tunnel, the left (east) tunnel was primarily a precaution in case waters diverted from Colorado River exceeded the capacity of the tunnel, measuring 41 feet in diameter, on the right. But this day it would serve its purpose, however short a period of time it lasted. The water did not take long to rise high enough to begin flowing into and out of the left (east) diversion tunnel. That 33-foot rise backed up the waters of the Colorado River 16 miles into the canyon. (Courtesy of Bureau of Reclamation, photo by A.E. Turner, P-557-420-7830, 1-24-63.)

Five

Backing Up the Waters of the Mighty Colorado

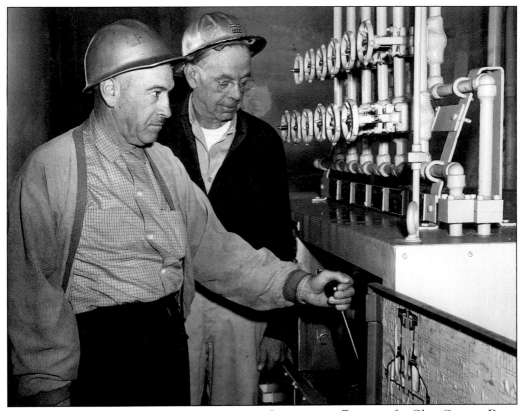

"L.R. Wylie, the Bureau of Reclamation Project Construction Engineer for Glen Canyon Dam, operates the control which lowers a hydraulic gate in the left [east] diversion tunnel to begin the storage of water in Lake Powell. Mr. Wylie is assisted by Walter R. Chubbuck, Inspector for the Bureau of Reclamation. Wylie lowered the gates at 2:00 p.m., March 13, 1963 to limit the flow passing the dam to just a trickle—1,000 cubic feet per second." (Courtesy of Bureau of Reclamation, photo by Stan Rasmussen, P-557-420-8078, 3-13-63.)

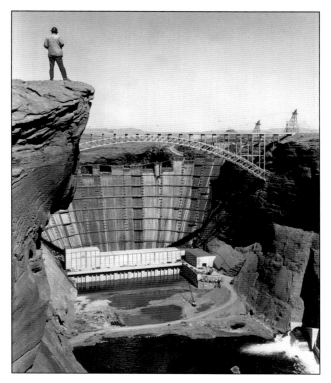

"A workman stands on a high rock looking upstream at the nearly completed Glen Canyon Dam. This photo was taken immediately prior to the partial closing of the left [east] diversion tunnel." March 13, 1963 was the officially recorded day when the high pressure gates were closed and the storage of water began, thus giving birth to Lake Powell. (Courtesy of Bureau of Reclamation, photo by W. L. Rusho, P-557-420-8081, 3-13-63.)

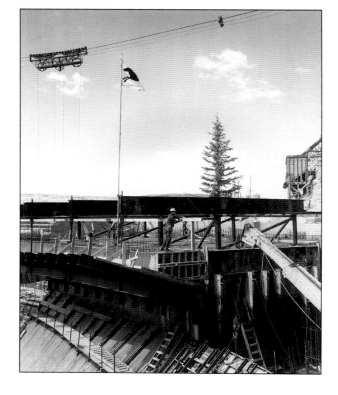

"A Christmas tree set up upon Block 2, first block to be topped out." Block 2 was topped out on a swing shift on March 30, 1963. The Christmas tree erected on it was decorated with lights and remained perched there for better than a week. (Courtesy of Bureau of Reclamation, photo by A.E. Turner, P-557-420-8180, 4-3-63.)

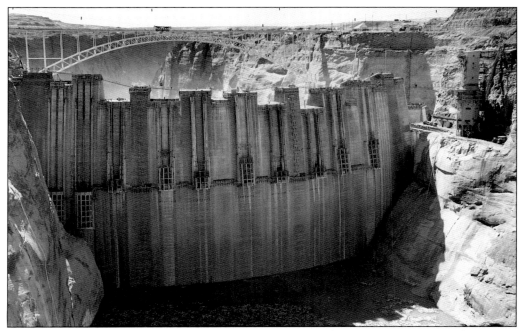

The upstream side of Glen Canyon Dam was photographed from the "chickenwire" footbridge. No longer does the transfer trestle extend as far south as it used to—the dam blocks that were under it have now risen above it. (Courtesy of Bureau of Reclamation, photo by A.E. Turner, P-557-420-8142, 3-22-63.)

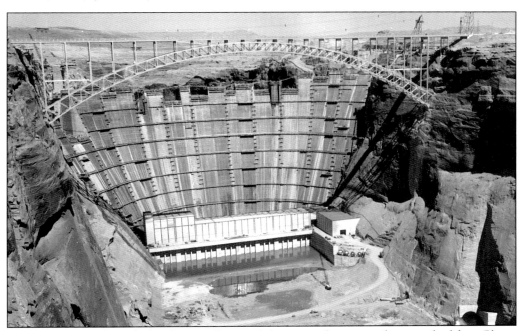

The downstream face of Glen Canyon Dam and the powerplant were photographed from Photo Point No. 1 approximately one-half mile downstream on the west rim. (Courtesy of Bureau of Reclamation, photo by A.E. Turner, P-557-420-8143, 3-22-63.)

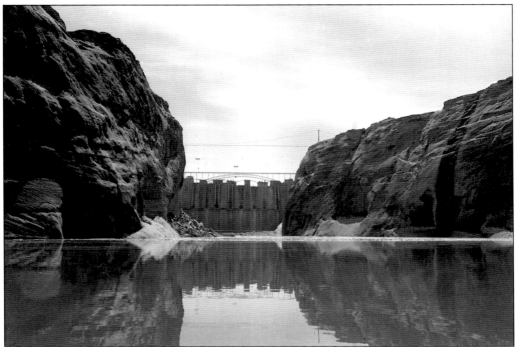

"A 'fish eye' view of Glen Canyon Dam as seen from a boat on the rising surface of Lake Powell. Lake elevation was 3,245 feet." (Courtesy of Bureau of Reclamation, photo by W.L. Rusho, P-557-420-8173, 4-5-63.)

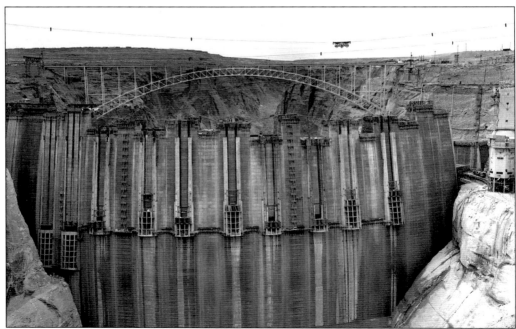

"Looking downstream at Glen Canyon Dam from footbridge." (Courtesy of Bureau of Reclamation, photo by F. Finch, P-557-420-8174, 4-11-63.)

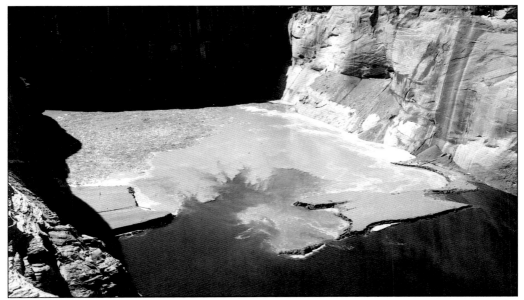

"Looking downstream at upper cofferdam. Dam broke through about 7:00 a.m." Since the closure of the gates on the left (east) diversion tunnel, water had been filling up behind the dam but also behind the coffer dam. The water rose high enough on this day in April that the coffer dam was breached, transforming it into no more than the bottom of the lake near the dam. (Courtesy of Bureau of Reclamation, photo by F. Finch; P-557-420-08191, 4-18-63.)

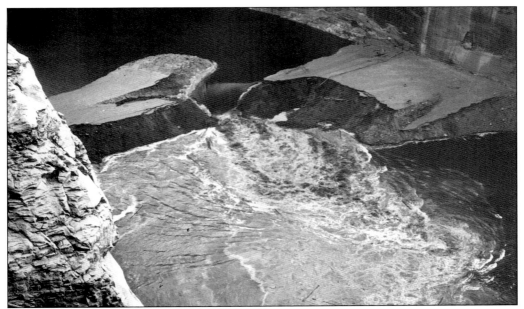

"Downstream sloughing of the earth filled cofferdam permits the rising Lake Powell to break through and fill the pool between the cofferdam and Glen Canyon Dam itself. This photograph was copied from a 35 mm slide taken by Omer Hill of Merritt-Chapman & Scott Corporation. The first break was noted shortly after 7:00 a.m. and this photograph was taken at 7:15 a.m." (Courtesy of Bureau of Reclamation, photo by Omer Hill, P-557-420-8244, 4-18-63.)

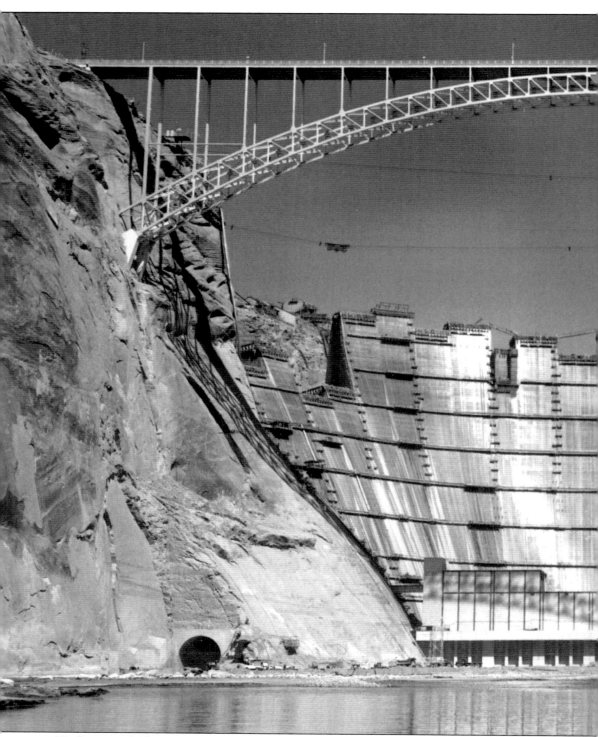

"Reflection of Glen Canyon Dam shimmers in the clear water of the Colorado River. Two of the high blocks of the dam, Blocks 2 and 4, on the right side in this photograph, have reached

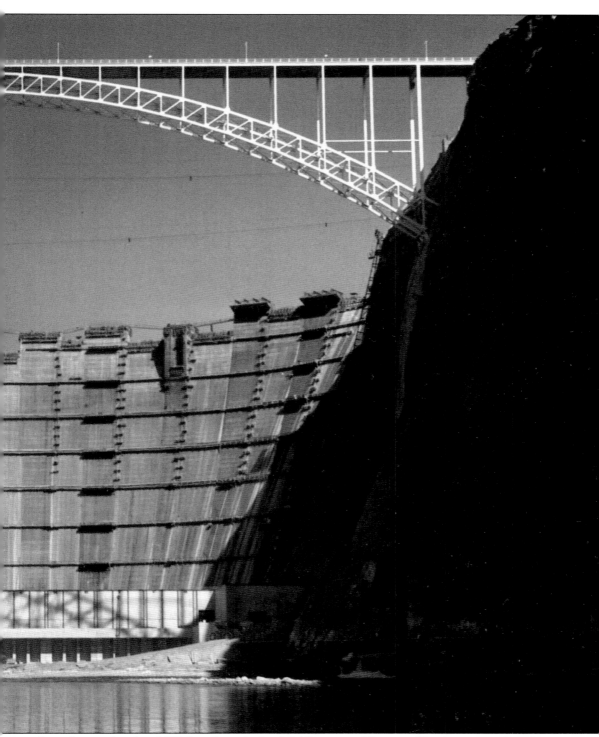
their ultimate height of 720 feet above bedrock." (Courtesy of Bureau of Reclamation, photo by W.L.Rusho, P-557-420-8184, 4-17-63.)

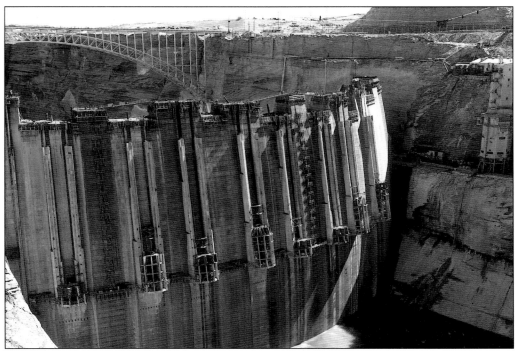

In this photograph of the upstream dam, work on the eight penstock intakes and trashracks is in various stages at each station. (Courtesy of Bureau of Reclamation, photo by A.E. Turner, P-557-420-8239, 4-18-63.)

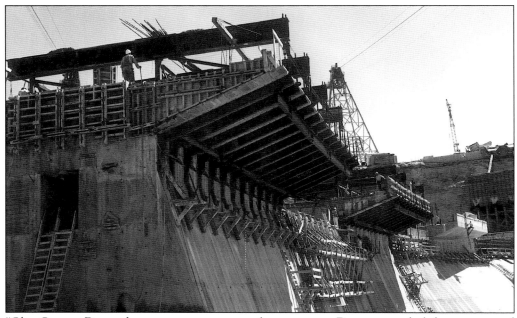

"Glen Canyon Dam—dam crest structure—cantilever supports. Downstream deck forms supported by overhead beams at downstream end and he-bolts at intersection with face of dam. (Block 6)." (Courtesy of Bureau of Reclamation, photo by A.E. Turner, P-557-420-8237, 4-24-63.)

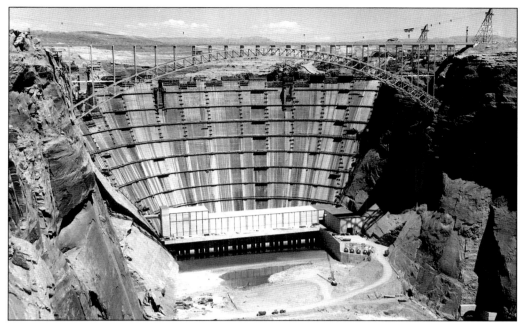

This weekly progress photo of the downstream side of Glen Canyon Dam taken from Photo Point No. 1 shows a dam structure nearing completion. It is at the top, at what will be the crest of the dam, where progress is most notable. (Courtesy of Bureau of Reclamation, photo by A.E. Turner, P-557-420-8250, 5-2-63.)

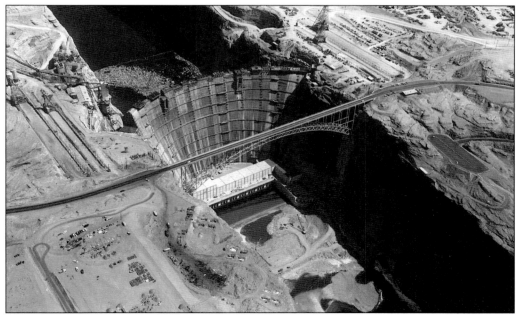

On the day this aerial photo was taken the elevation of the Lake Powell reservoir behind the dam had risen to 3,301.8 feet. The crest of the dam would be 3,715 feet above sea level and the reservoir would rise to 3,700 feet when full—only 400 feet to go. (Courtesy of Bureau of Reclamation, photo by A.E. Turner, P-557-420-8303, 5-15-63.)

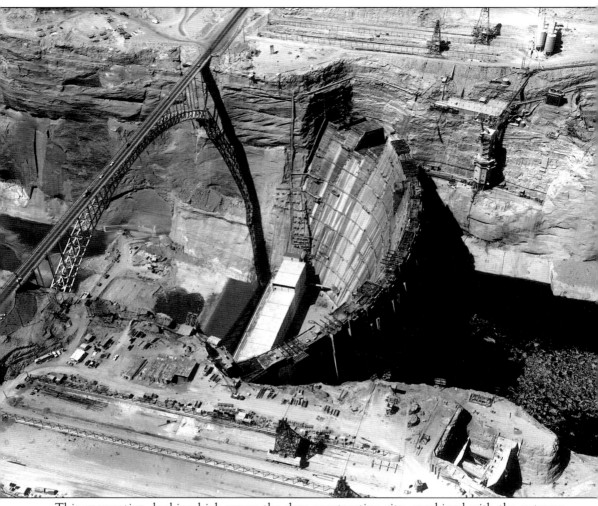

This perspective, looking high across the dam construction site, combined with the extreme clarity of this photograph afford a clear view of the various systems required to build the dam. Glen Canyon Bridge was vital as an efficient and expedited manner to transport materials. The right (west) diversion tunnel, used to facilitate the flow of water, has been plugged. Running from the east rim head frames to the west rim head frames, cables for each of the 50-ton cableways are taut and visible. Below the west rim cableway head frames are the batch plant and the transfer trestle; above and to the left are various structures and elements associated with its workings. Note the cooling towers and the good view of left (east) spillway. A long progression of steps can be seen leading to the two structures at the top of the monkey slides. (Courtesy of Bureau of Reclamation, photo by A.E. Turner, P-557-420-8299, 5-15-63.)

"Looking upstream at Glen Canyon Dam and Powerplant from Adit 8 in the powerplant access road tunnel." (Courtesy of Bureau of Reclamation, photo by A.E. Turner, P-557-420-8510, 6-13-63.)

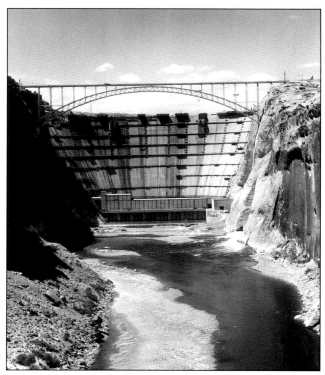

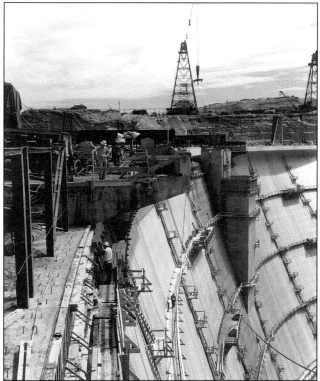

"Looking east along the downstream face of Glen Canyon Dam. Note overhang for roadway on top and gantry crane being erected in background." Below, on the downstream face of the dam structure, the temporary construction of an intricate pattern of ladders and supported "catwalks" are clearly visible. The workman on the "catwalk" gives perspective as to the size of this dam. (Courtesy of Bureau of Reclamation, photo by A.E. Turner, P-557-420-8676, 8-8-63.)

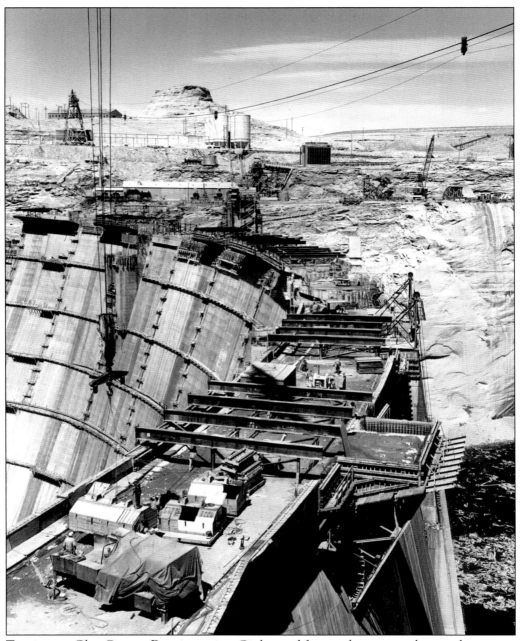

Topping out Glen Canyon Dam is nearing. Girders and formwork are set so that overhangs may be poured, making the top wide enough for a road along which service vehicles may drive, as well as the gantry crane on its rails that will glide from one end to the other to service the penstocks. (Courtesy of Bureau of Reclamation, photo by A.E. Turner, P-557-420-8509, 6-12-63.)

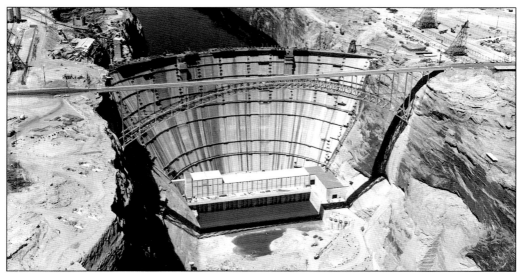

"Construction techniques at Glen Canyon Dam contrast sharply with work on Nagarjunasagar Dam in India. Specially-designed modern equipment such as 50-ton capacity, high-speed cableways enabled Merritt-Chapman & Scott construction crews to place concrete at an average daily rate of 8,000 cubic yards. On the Indian project 35,000 laborers hand-carry up long ramps built on matchstick-like bamboo scaffolding along the face of the dam. At peak of construction, Glen Canyon work force numbered 2,300." (Text courtesy of *Black Horse News*, winter 1963–1964; photo used in *Black Horse News*, courtesy of Bureau of Reclamation, photo by A.E. Turner, P-557-420-8690, 8-11-63.)

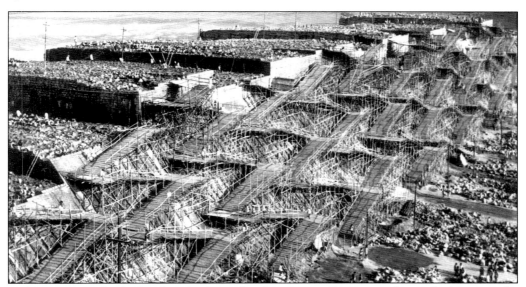

"What appears to be the handiwork of a toothpick artist is really a series of ramps built against the face of Nagarjunasagar Dam in India. The country short of machinery but long on laborers had to move 190,200,000 cubic feet of masonry and concrete and to move 1,739,000,000 cubic feet of earth and rock in a round the clock operation. The laborers carry the materials up the ramps to the top of the dam. The final result will be 3,100 feet long and 404 feet high." This photograph was entitled by the writer, "Dam Ramps." (Courtesy of Wild World Photos, 6-21-63.)

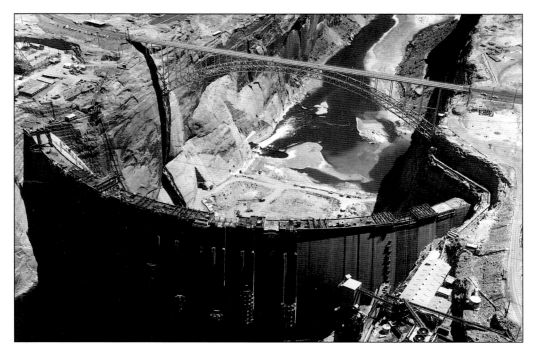

These two aerial progress photos were taken only a month and days before placing the last bucket of concrete. In all, 5,370,000 yards of concrete would be poured—4,901,000 yards on the dam alone, the rest on the powerplant. (Courtesy of Bureau of Reclamation, photos by A.E. Turner, P-577-420-8687 and P-557-420-8689, both 8-11-63.)

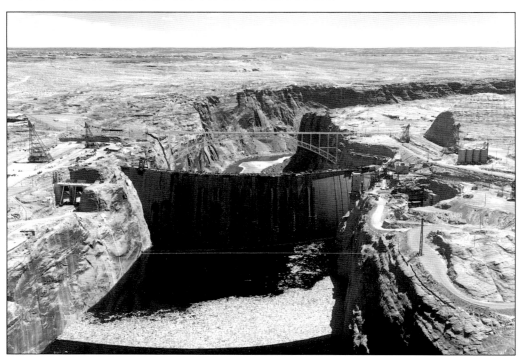

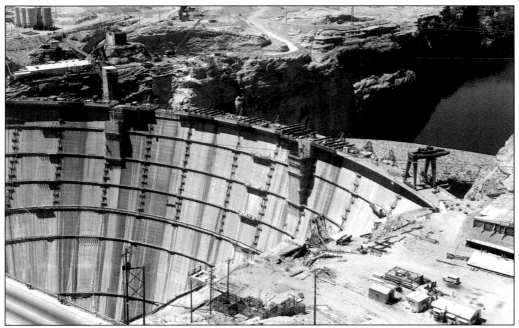
In this view of the east end of the dam the gantry crane is visible at the far right. Driven by a 40-horsepower, 1,200-rounds-per-minute direct-current motor, the gantry crane is capable of lifting 165 tons with its larger hoist and 25 tons with the smaller one. (Courtesy of Bureau of Reclamation, photo by A.E. Turner, P-557-420-8692, 8-11-63)

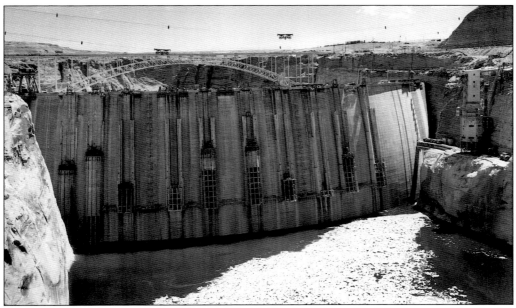
Comparing this photograph of August 15, 1963 taken from the "chickenwire" footbridge to the photograph on page 95 of March 22, 1963, the waters of Lake Powell have risen dramatically in just six months. (Courtesy of Bureau of Reclamation, photo by A.E. Turner, P-557-420-8701, 8-15-63.)

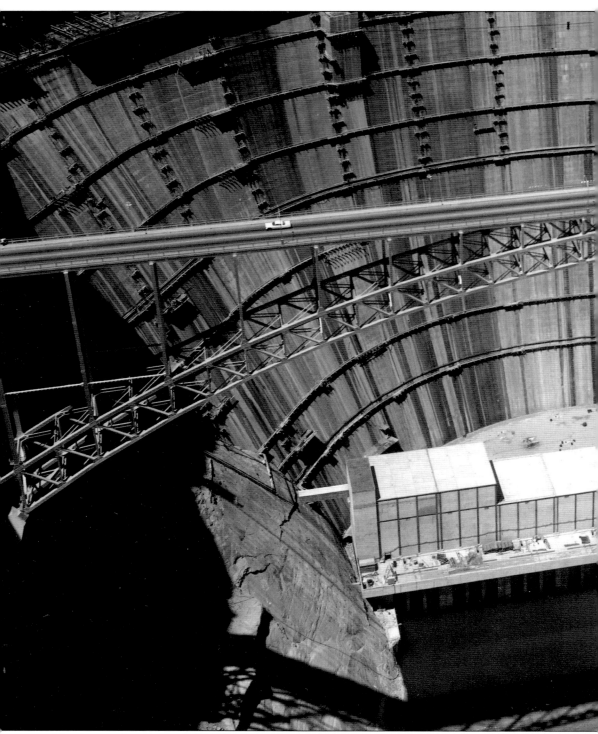

Up close and very detailed, this aerial photograph looking north at Glen Canyon Dam, Glen Canyon Bridge, and the powerplant—although one dimensional—might lead readers to believe

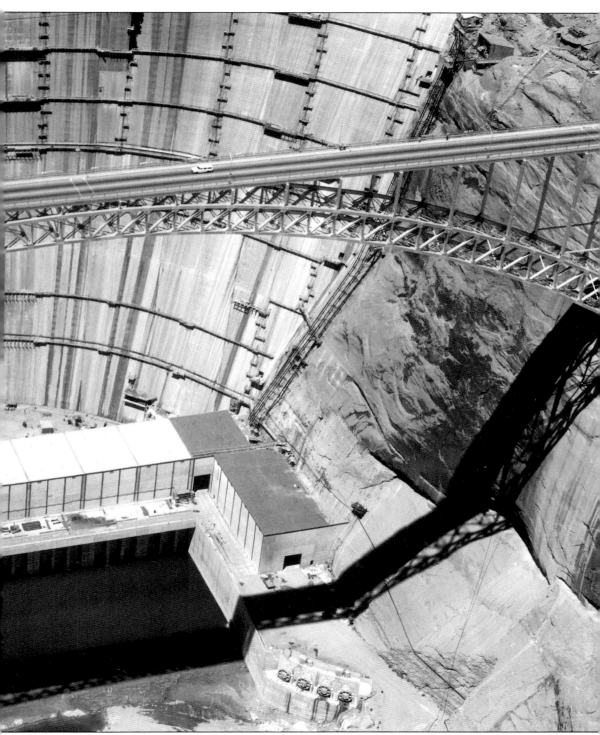

they could reach out and touch the bridge. (Courtesy of Bureau of Reclamation, photo by A.E. Turner, P-557-420-8691, 8-11-63.)

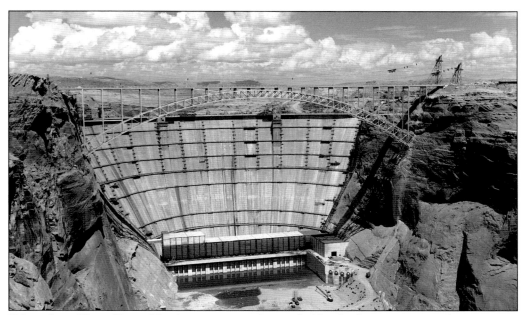

Taken from Photo Point No. 1, approximately one-half mile downstream on the west rim, this is the last progress photo of concrete placement. It was taken just days before the last bucket of concrete was poured. (Courtesy of Bureau of Reclamation, photo by A.E. Turner, P-557-420-8744, 9-5-63.)

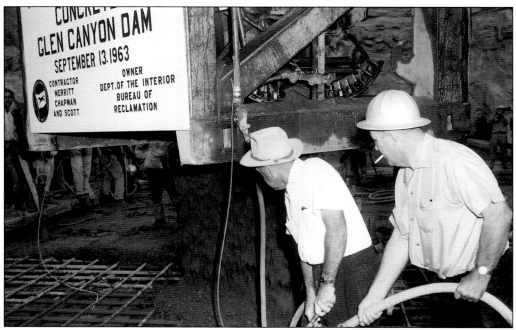

"L.F. Wylie, Project Construction Engineer for the Bureau of Reclamation (left), dumps the last bucket of concrete into Glen Canyon Dam. He is assisted by Jim Irwin, Project Manager for the prime contractor, Merritt-Chapman & Scott Corporation." (Courtesy of Bureau of Reclamation, photo by Mel Davis, P-557-420-8794, 9-13-63.)

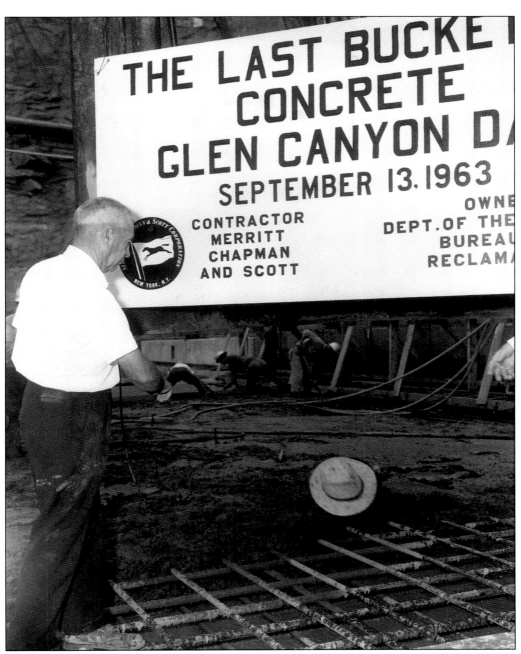

"L.F. Wylie, Project Construction Engineer for the Bureau of Reclamation, throws his old hat under the last bucket of concrete, where it was buried. Wylie had worn the hat since work began on Glen Canyon Dam in 1956." (Courtesy of Bureau of Reclamation, photo by Mel Davis, P-557-420-8796, 9-13-63.)

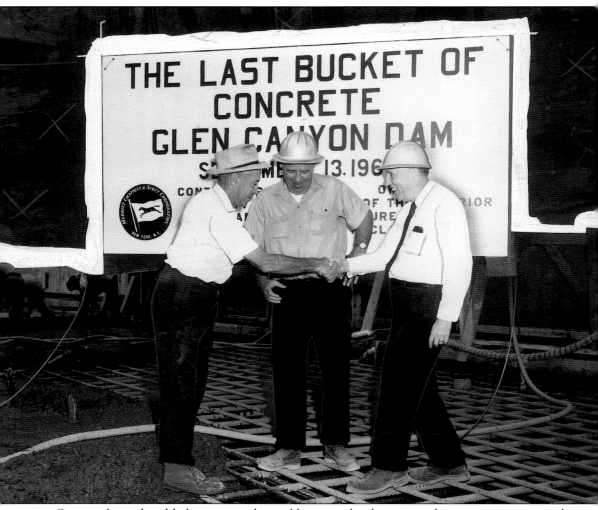

Congratulatory handshakes were exchanged between the three men who were so instrumental in the management and construction of Glen Canyon Dam. L.F. Wylie (left) the project construction engineer for the Bureau of Reclamation, shakes the hand of M.C. McGough (right), executive vice president for construction of Merritt-Chapman & Scott, while James G. Irwin, project manager of Merritt-Chapman & Scott, looks on. (Courtesy of Bureau of Reclamation, P-557-420-8797, 9-13-63.)

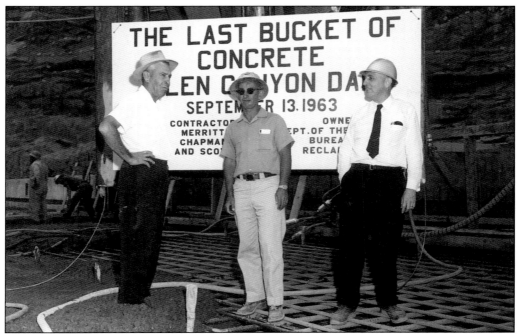

"L.F. Wylie [left], Project Construction Engineer for the Bureau of Reclamation; Curtis Glass [center], Merritt-Chapman & Scott General Superintendent; and M.C. McGough [right], Executive Vice President for construction pose in front of the last bucket of concrete sign." (Courtesy of Bureau of Reclamation, P-557-420-0879, 9-13-63.)

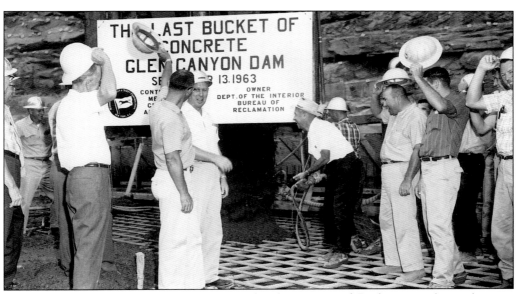

"L.F. Wylie, Project Construction Engineer for the Bureau of Reclamation (center), turns the valve releasing the last 12 cubic yards of concrete on to Glen Canyon Dam. In the left foreground [from left to right] are Norman Keefer (white shirt), Curtis Glass, and Bernie Baxter. At right [left to right] are Herb Parson, Robert Delarm, and Vincent Kelly." (Courtesy of Bureau of Reclamation, photo by Mel Davis, P-557-420-8793, 9-13-63.)

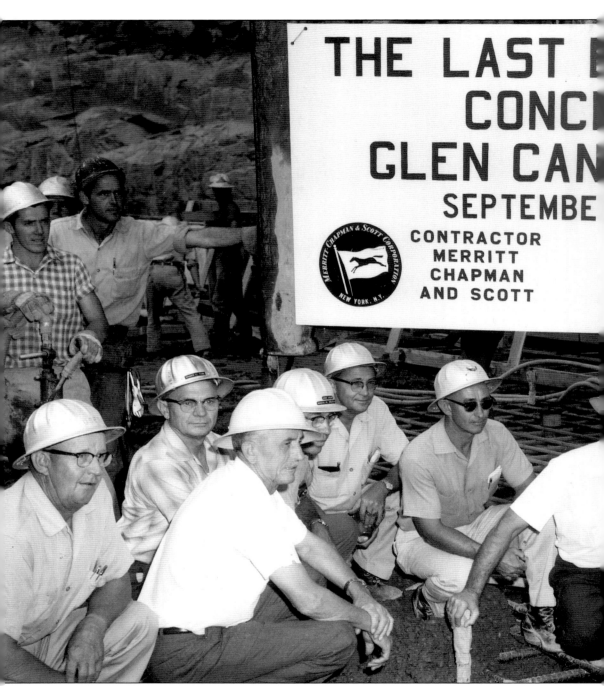

Merritt-Chapman & Scott supervisory personnel and Bureau of Reclamation engineers gather for a Glen Canyon Dam "family photo" as the last bucket of concrete is placed. Kneeling, from left to right, are Vic Gezalius, Howard Fink, Norm Keefer, and Vaud Larson all of the Bureau of Reclamation; grouting superintendent Aubrey Walker and general superintendent Curt Glass, both with Merritt-Chapman & Scott. Kneeling at center is L.F. Wylie, and to the right are, from left to right, Art Moren, master mechanic; Bernie Baxter, piping superintendent;

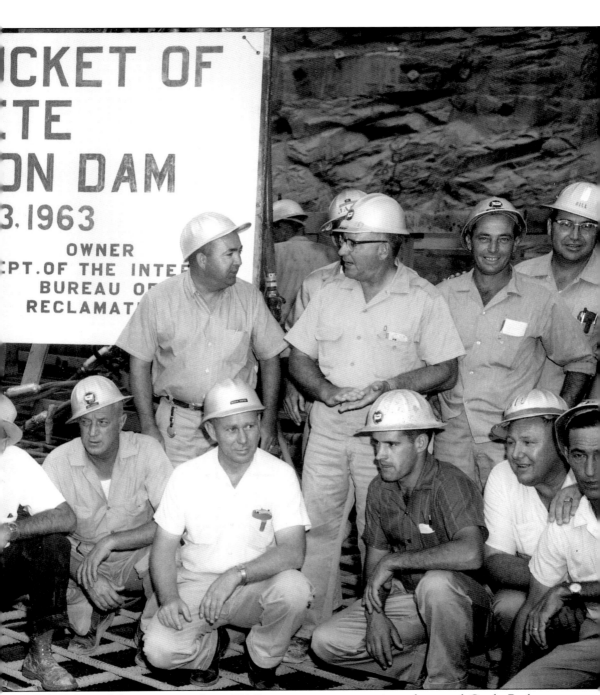

Bob Delarm, labor superintendent; Sid Snapp, carpentry superintendent; and Grady Butler, millwright superintendent. Standing on the right side, from left to right, are Herb Parsons, foreman; Jack Desart, chief field engineer; Bill Dollarhide, trashrack superintendent; and Bill Baldwin, assistant carpentry superintendent. The two men standing on the left are unidentified. (Courtesy of Bureau of Reclamation, photo by Mel Davis, P-557-420-8804, 9-13-63.)

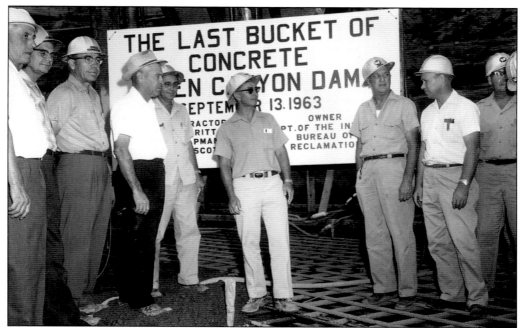

Celebrating the long-awaited last bucket of concrete are, from left to right, Norm Keefer, Howard Fink, Vaud Larson, and L.F. Wylie, all of the U.S. Bureau of Reclamation; Aubrey Walker, Curtis Glass, Art Moren, Bernie Baxter, and Jack Desart, all of Merritt-Chapman & Scott Corporation. (Courtesy of Bureau of Reclamation, photo by Mel Davis, P-57-420-8799, 9-13-63.)

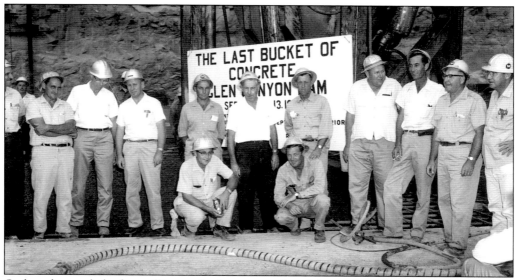

Gathered to mark the five million yard milestone are, from left to right, F.G. Dunkel, Blackie Hunt, John Nigh, Bernie Baxter, and Bill Dollarhide, all of Merritt-Chapman & Scott Corporation; L.F. Wylie, project construction engineer for the Bureau of Reclamation; Gib Carter, Sid Snapp, Grady Butler, Jack DeSart, and Bill Baldwin, all of Merritt-Chapman & Scott Corporation. Squatted in front are Aubrey Walker and M.P. Baker, both of Merritt-Chapman & Scott. (Courtesy of Bureau of Reclamation, photo by Mel Davis, P-557-420-8800, 9-13-63.)

"Workmen on travel stage apply hot bitumastic coal tar enamel using fibre brushes to interior of penstock—lower horizontal section. From left to right workmen are Mike Schmidt, Jim Kane, J. Blake." (Courtesy of Bureau of Reclamation, photo by A.E. Turner, P-557-420-8813, 9-14-63.)

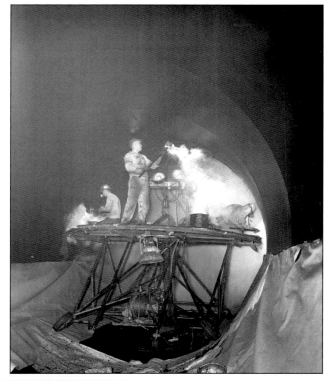

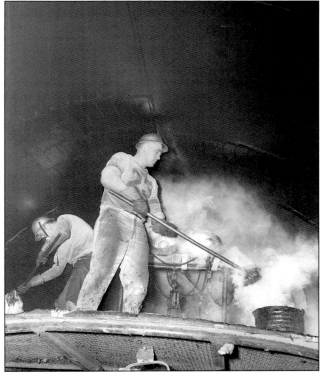

"Jim Kane, foreground, and Mike Schmidt apply hot coal tar enamel to interior of penstock, lower horizontal Section P-8-24. Note shingle pattern application." (Courtesy of Bureau of Reclamation, photo by A.E. Turner, P-557-420-8815, 9-12-63.)

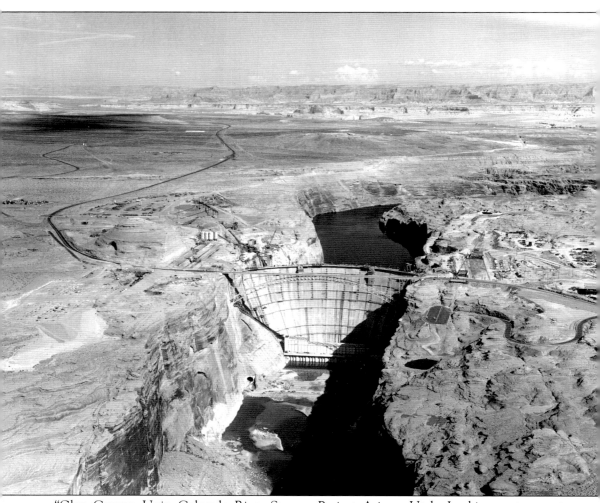

"Glen Canyon Unit, Colorado River Storage Project Arizona-Utah. Looking upstream at Glen Canyon Dam and Powerplant." Lake Powell had been rising behind the dam structure for four months. The last bucket of concrete was placed the day before this photo was taken in September 1963, and yet work on the project would continue for another two and a half years, when the last generator in the power plant would be completed on February 28, 1966. (Courtesy of Bureau of Reclamation, photo by A.E. Turner, P-557-420-8822, 9-12-63.)

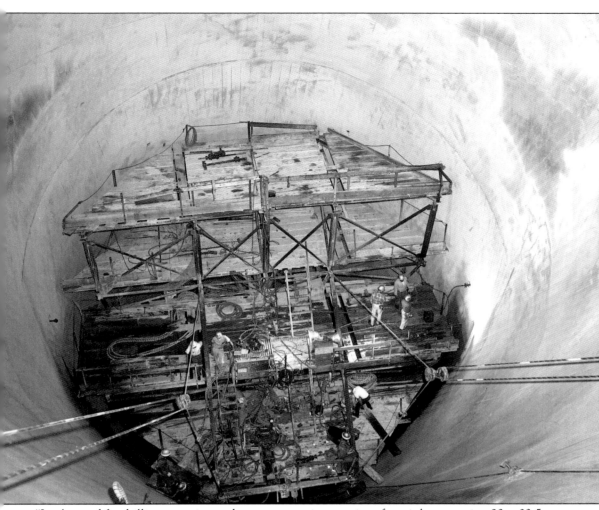

"Jumbo used for drilling, grouting and concrete repair operations from inlet to station 23 + 03.5, left (east) spillway, Glen Canyon Dam." Although the upstream portion of the west and the east diversion tunnels were plugged when their use was no longer needed, the lower portion of each was not. After water was allowed to begin backing up behind the dam, the lower portion of each diversion tunnel then became a part of the east and west spillway including the discharge of each. (Courtesy of Bureau of Reclamation, photo by A.E. Turner, P-557-420-8971, 10-14-63.)

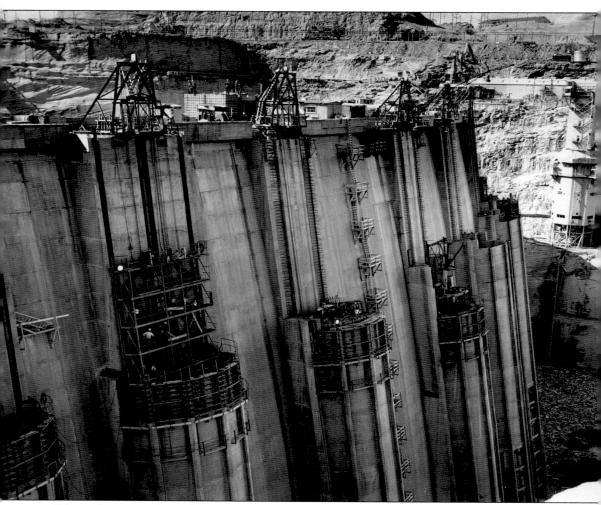

The eight penstock intakes on the upstream side of the dam are protected with trashracks, which are still under construction in this and the photo on the following page. The screened portion of the structure is intended to keep fish and debris from entering the penstock opening, which is 15 feet in diameter. The intake into each penstock could be increased or decreased by fixed-wheel gates controlled by hydraulic hoists in control houses above. (Courtesy of Bureau of Reclamation, photo by A.E. Turner, P-557-420-8987, 10-23-63.)

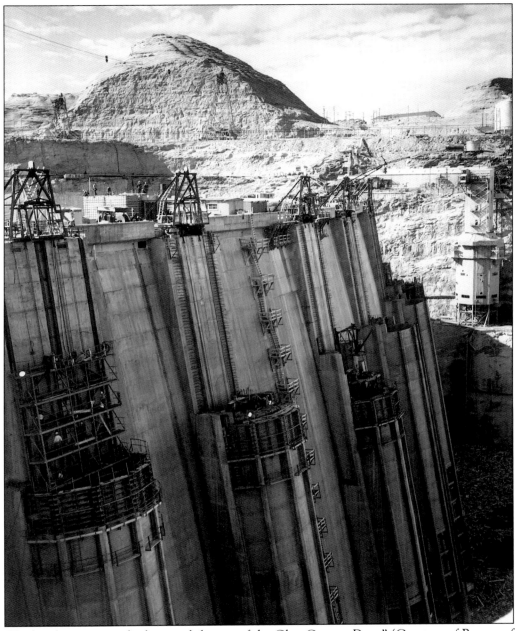
"Trashrack structures climb toward the top of the Glen Canyon Dam." (Courtesy of Bureau of Reclamation, photo by A.E. Turner, P-557-420-8988, 10-23-63.)

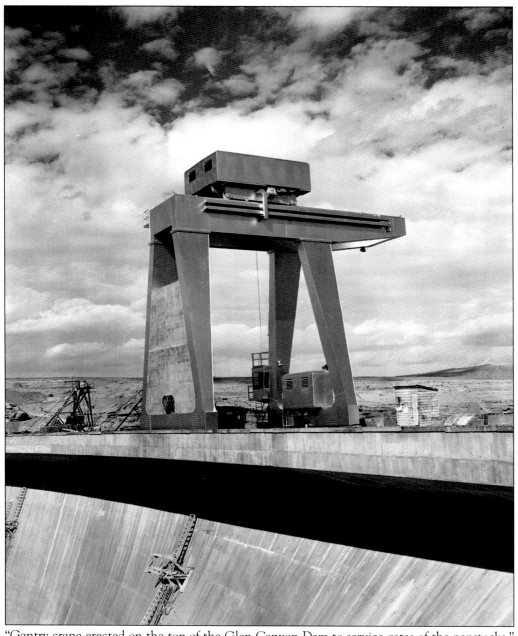

"Gantry crane erected on the top of the Glen Canyon Dam to service gates of the penstocks." (Courtesy of Bureau of Reclamation, photo by A.E. Turner, P-557-420-8991, 10-23-63.)

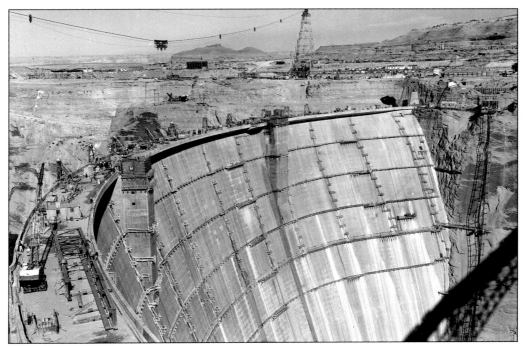
"Looking across Glen Canyon Dam from west rim. Assembly in foreground is west bridge to dam top. Elevator towers nearing completion." (Courtesy of Bureau of Reclamation, photo by A.E. Turner, P-557-420-9072, 11-15-63.)

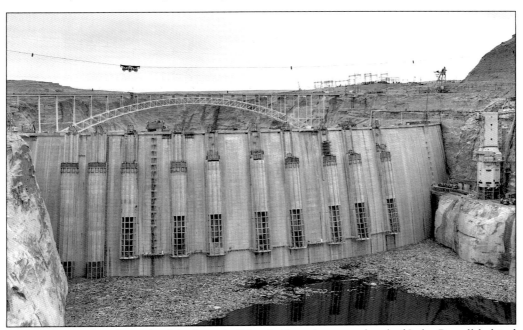
In this photo taken from the "chickenwire" footbridge, the water level of Lake Powell behind Glen Canyon Dam has risen and is nearing the bottom of the penstock intakes. (Courtesy of Bureau of Reclamation, photo by A.E. Turner, P-557-420-9066, 11-21-63.)

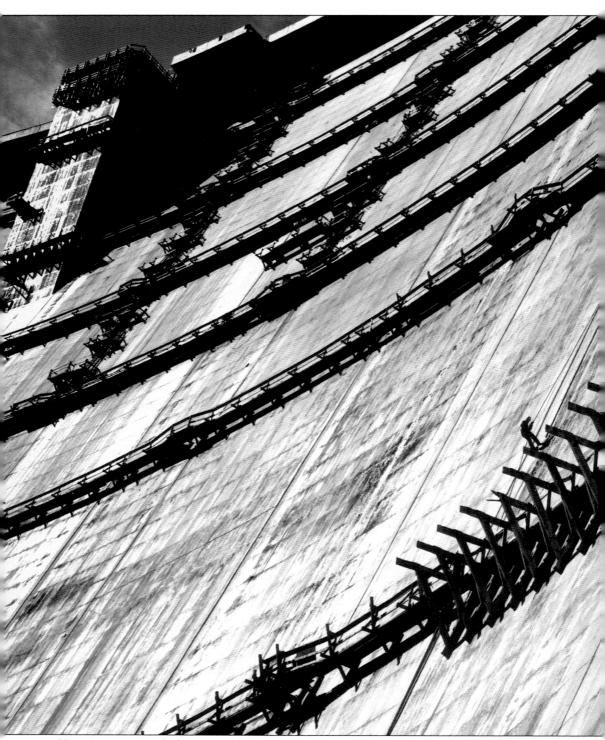
Hanging precariously from ropes tied to a harness, crews are seen scraping and dry packing holes in the downstream face of the dam after removal of the ladder and "catwalk" system brackets.

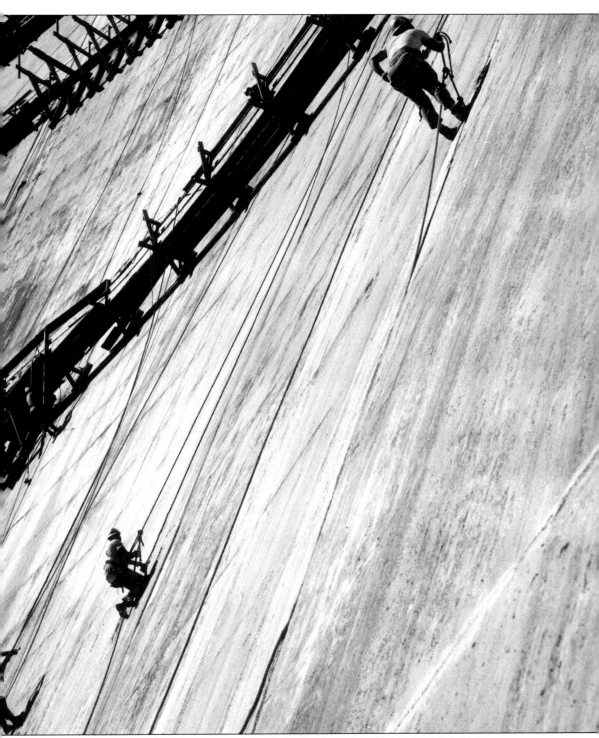

(Courtesy of Bureau of Reclamation, photo by F. Finch, P-557-420-8933, 10-4-63.)

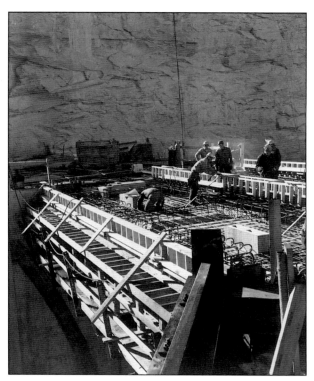

"Workmen at work on reinforcing steel and concrete forms on right spillway." (Courtesy of Bureau of Reclamation, photo by A.E. Turner, P-557-420-9069, 11-13-63.)

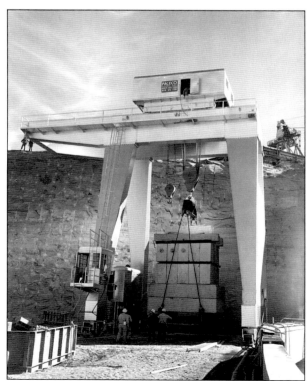

"165-ton gantry crane is tested with a weight of $206 1/4$ tons." (Courtesy of Bureau of Reclamation, photo by A.E. Turner, P-557-420-9073, 11-18-63.)

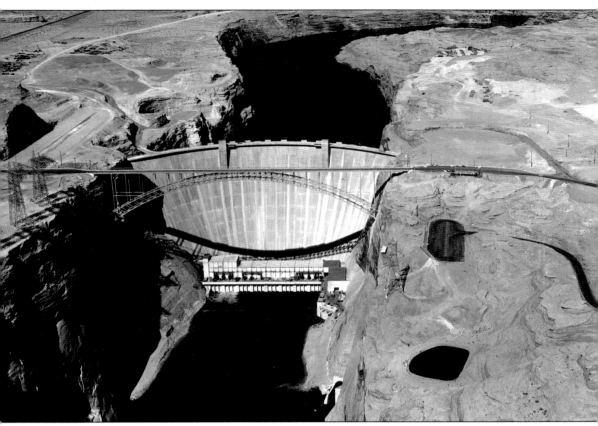

It would appear that with all of the construction equipment gone that Glen Canyon Dam was finally complete. It was not. Despite construction equipment no longer in plain view, work inside the power plant continued. Installation of the last of eight generators did not occur until February 1964, and all eight of the generators were not fully operational and sending power across miles of draping transmission lines until early 1966. Then, in October of that year, just days shy of a decade since President Eisenhower had set off that first blast, Glen Canyon Dam was dedicated. Lady Bird Johnson, a host of dignitaries, and throngs of people attended the ceremony. The job was finally done. (Courtesy of Bureau of Reclamation, photo by F. Finch, P-557-420-10290, 10-21-64.)

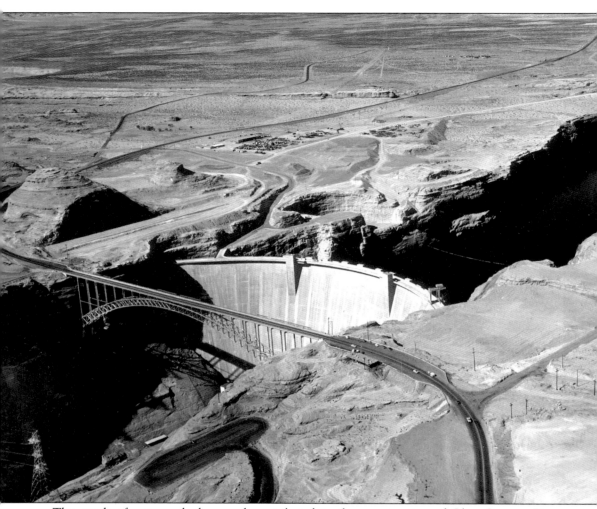

Thousands of men worked on and contributed to the construction of Glen Canyon Dam. Eighteen men were killed on the project, and since that period of time almost 50 years ago, many of the names and faces associated with the project have passed on. All that is left now is the dam itself, the lake behind it, the bridge, a visitor center, a few old and retired construction hands, and, of course, these images. At the very bottom of the dam blocks, locked deep inside each lift of concrete, are the voices of those men who came to Glen Canyon to do a job and make a living. Many of the stories that could be told of the work and the life that revolved around it are, if they have not been passed on by now, lost forever. There are some writings that speak of the men and their families who lived there high on Manson Mesa when it, and Glen Canyon, were still a remote and a far away place, but there is not nearly enough. Pictures tell a story, and one cannot help but look ever so closely at each photograph and strain to hear those deep and buried voices. (Courtesy of Bureau of Reclamation, photo by F. Finch, P-557-420-10289, 10-21-64.)